THEN & NOW

SANTA CRUZ COAST

Opposite: Santa Cruz originally developed as a shipping port for lime, leather, and lumber, but following an 1862 convention of city leaders from San Francisco in Santa Cruz, the city's resort potential became apparent. In 1864, the first hot saltwater baths opened to serve visitors who found the cold waters of the bay uninviting. The Long Branch Baths had a waist-deep pool, and it was soon followed by other bathhouses that clustered around the river mouth and the site of the present boardwalk. The Liebbrandt brothers opened the Dolphin Baths, the West's first hot saltwater plunge, with a large main floor pool and an upstairs ballroom, in 1868. The baths were located just east of the present Neptune's Kingdom and were a resounding success. By 1873, an estimated 1,000 people a day enjoyed the bathing pool in the summer months, generating large profits. The Dolphin Baths were followed in 1879 by Wheaton's Bathhouse, which was envisioned to provide "that completeness which tends to the comfort of patrons— people of refinement and taste." Capt. Fred Miller bought out Wheaton's bathhouse in 1885 and integrated separate-sex pools for mixed-gender use as the Neptune Baths. Fred and his brothers, Ralph and Albert, were Santa Cruz natives and elevated the Neptune Baths to one of the city's finest bathing resorts.

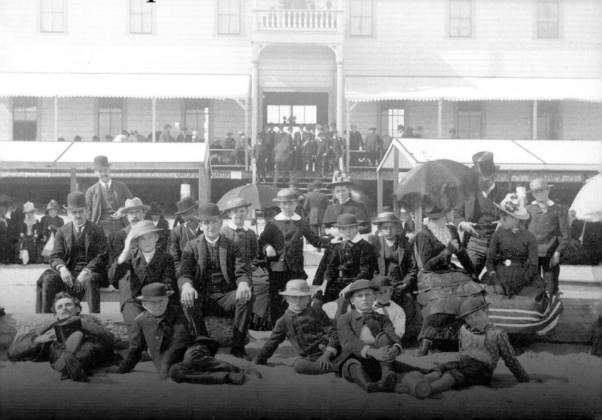

THEN & NOW

SANTA CRUZ
COAST

Gary Griggs and
Deepika Shrestha Ross

This book is dedicated to our children and grandchildren, Joel, Maica, Dylan, Amy, Shannon, Callie, Cody, and Mayadevi, who we hope will enjoy the coast, appreciate the change and evolution that it constantly undergoes, and that they will take the time to appreciate this unique treasure that we are fortunate enough to call home.

Library of Congress control number: 2006926307

Published by Arcadia Publishing
Charleston SC, Chicago IL, Portsmouth NH, San Francisco CA

Printed in the United States of America

For all general information contact Arcadia Publishing at:
Telephone 843-853-2070
Fax 843-853-0044
E-mail sales@arcadiapublishing.com
For customer service and orders:
Toll-Free 1-888-313-2665

Visit us on the Internet at www.arcadiapublishing.com

On the Front Cover: Natural Bridges is seen at top in a 2006 photograph taken by author Deepika Shrestha Ross. The *c.* 1900 photograph below shows Natural Bridges with beachcombers. (Courtesy of Special Collections, University Library, University of California Santa Cruz.)

On the Back Cover: Seabright Castle is buffeted by large waves in 1953. (Courtesy of Special Collections, University Library, University of California Santa Cruz.)

Contents

Acknowledgments vii

Introduction ix

1. Davenport to Natural Bridges State Beach 11

2. West Cliff Drive 29

3. Cowell's Beach and the Boardwalk 47

4. Seabright Beach to Pleasure Point 61

5. Capitola to Rio Del Mar 77

ACKNOWLEDGMENTS

While we were aware of a handful of old coastal photographs at the time we started this project, we soon realized that there were many more images out there that had been carefully stored, cared for, and catalogued by a small group of dedicated librarians and historians. Without their assistance, this book would not have been possible, and we are grateful for the help and information that these people have generously provided.

Sandy Lydon, a very close friend and well-loved local historian who taught at Cabrillo College for nearly 40 years, generously shared his knowledge of local history, provided a key photograph, and also carefully edited all of our text. We are indebted to Frank Perry, coastal historian and geologist, who gave us free reign to use his collection of historical photographs, including a wonderful collection of old post cards of the Santa Cruz coast. Frank reviewed all of our writing and was an important source of information, helping us identify and date the old photographs. Carolyn Swift, resident historian and director of Capitola's historical museum was an invaluable source of information on the old photographs of the Capitola area, and we are grateful for her help.

Christine Bunting, head of special collections at the University of California Santa Cruz McHenry Library, provided access to the many old photographs in their collection. We are grateful to Jennifer Lienau Thompson, the curator at the Santa Cruz Museum of Natural History, who graciously provided us access to the museum's special collection of historical photographs. Likewise, Merritt Taylor of the Santa Cruz City–County Library System was very helpful in locating the library's collections and allowing us access to the old coastal images.

Richard Beal generously shared with us all the wonderful old photographs of the Santa Cruz Boardwalk that he and his daughter had compiled for their book. Alverda Orlando, north coast historian, dug through her collection of old photographs from the Davenport area and kindly gave them to us to use. Harold J. van Gorder, now 105 years old, and his son Jud graciously permitted us to use several photographs from Harold's fantastic collection. Also, Edie Rittenhouse shared her turn-of-the-century family photographs with us, several of which were taken along the Santa Cruz coast. We also want to thank the Art and History Museum at the McPherson Center, Covello and Covello photographers, and Rogers E. Johnson, who allowed us to use some of their historical photographs of the Santa Cruz coastline.

For the photos taken from the air, we are indebted to Ken and Gabrielle Adelman, superb helicopter pilots and photographers, who enthusiastically and effortlessly got us to all the locations on our list and took some of the photographs as well.

INTRODUCTION

Located along the northern edge of Monterey Bay, Santa Cruz's mild climate and abundant natural resources have drawn entrepreneurs, visionaries, and tourists to its shores for well over 100 years. Tourists came to enjoy the sun, salt water, and beaches that span the coastline from Davenport to Santa Cruz, to Capitola and Rio Del Mar, while captains of industry, fishermen, movie stars, and mountain men all made their homes here next to farmers and loggers, artists and hippies, and, more recently, Silicon Valley dot-commers.

Santa Cruz County was created in 1850 as one of the new state of California's original counties, and the city of Santa Cruz received its charter 26 years later, in 1876. As the population of both county and city grew, it became home to hotels and beachfront mansions, cottage cities and tent camps, and even a classic seaside amusement park. The county's coastline has something for everyone, from the rugged, wave-swept, windy and picturesque north coast, to the sandy beaches of northern Monterey Bay, an ideal holiday retreat for a growing number of people seeking respite from the heat of inland cities.

They came first by rail and later by road. In fact, the county's popularity gave rise to an ambitious proposal by the Ocean Shore Railway to construct a coastal railroad connecting San Francisco to Santa Cruz. In 1928, aerial photographs of the coastline from Año Nuevo to the Pajaro River were taken to help plan the route. Although much of the railway was developed, the project was never completed, as the coastline in several places was just too rugged. These photographs, however, provide a unique record of the coastline from which comparisons can be made today.

The earliest dated photograph of the Santa Cruz coast was taken about 140 years ago. It appears that as soon as cameras became widely available, residents, visitors, and commercial photographers began to take pictures of the coastline and beaches from one end of the county to the other. The picturesque arches, sea stacks, and distinct rock formations along West Cliff Drive were photographed frequently, memorialized in hand-colored postcards, and saved for posterity in family albums.

Over subsequent years, winter storms have battered the ocean bluffs and beaches, sea level has gradually risen, and the coastline has slowly retreated. Some areas have changed dramatically, while others have surprisingly changed very little. The natural bridges, arches, and sea stacks that owe their origins to wave attack of the weaker sandstones and mudstones have been destroyed by the very same forces that created them. Castles, gazebos, lighthouses, homes and hotels, streets and piers have all come and gone. The county's retreating coastline and our attempts to enjoy it, develop it, and profit from it have all been captured over time in many fascinating and revealing photographs.

The coastline and beaches are among Santa Cruz County's most popular natural resources. Our objective with this book has been to document the changes that the coastline and beaches have undergone through a series of then-and-now photographs. We believe that there is an inherent interest in seeing how the coastline has changed visually over time through a series of side-by-side comparison of old and present-day photographs.

The available historic coastal photographs set the stage for what areas we chose to rephotograph. The challenge was in selecting the most interesting older photographs that also included some features recognizable today, and then attempting to reoccupy, as closely as possible, the same sites for a companion photograph. In the process, it became clear that a number of photographs were taken from natural or man-made structures that no longer existed. For challenges such as reoccupying two particularly wonderful views of the West Cliff area that were taken from the top of a tower holding a salt water storage tank near Natural Bridges over a century ago, we relied on the helicopter and piloting skills of friends Ken and Gabrielle Adelman (www.californiacoastline.org), who helped us rephotograph several sites.

The photograph sequences are a mix of both natural features like arches, bridges, and interesting rock formations, as well as the developed or altered coastline that includes piers, castles, hotels, and many other structures that no longer exist. Natural Bridges State Beach, for example, was originally named for the three natural bridges along the headland at the beach's southern end. Today, as a result of wave attack, only a single bridge remains. Castle Beach, as it is still called by longtime residents, was named for a castle built along the low bluff at the back beach in the Seabright area. Historically, the beach here was very narrow and the castle was regularly threatened by winter waves. While the castle no longer exists, there are many historic photographs of this picturesque structure. Today the bluff is protected by a 500-foot wide stretch of beach (Seabright Beach), a result of sand accumulation against the west jetty of the Santa Cruz Small Craft Harbor, which was constructed between 1962 and 1964.

Today much of coastline of northern Monterey Bay has been armored with seawalls and protective riprap to slow cliff retreat, but the old photographs give us a glimpse of what it was like in the days before human intervention. Residents of that time appear to have had a much greater respect for the temporary nature of the shoreline and, unlike today, when multimillion-dollar homes are built as close to the ocean as possible—some even right on the beach, the old houses were usually set back a reasonable distance from the edge of the cliff or bluff.

We have chosen to focus on coastal changes from Davenport to Rio del Mar, an area where most of the earliest Santa Cruz coastal photographs were taken. Many of the original photograph locations were easy to recognize, but others were much more difficult to relocate, simply because so much change has taken place over the course of a century. We also had the additional challenge of trying to make every pair of photographs interesting and informative. In some cases, however, grand 100-year-old buildings, Victorian ladies in broad brimmed hats, and horse-drawn wagons have given way to buildings of dubious architectural merit and seas of asphalt and parked cars. In the end, we did the best we could with what was available, trying to select images that we felt had a story to tell and were visually interesting from a then-and-now perspective.

CHAPTER 1

DAVENPORT TO NATURAL BRIDGES STATE BEACH

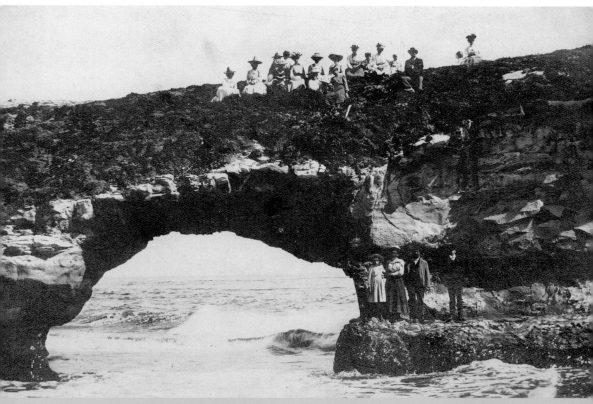

Twenty-one early visitors to Natural Bridges (*c.* 1900) sit atop the innermost arch and stand below it for a group photograph, a common custom at the time. This arch finally collapsed during a storm in the winter of 1980. (Courtesy of Special Collections, University Library, University of California Santa Cruz.)

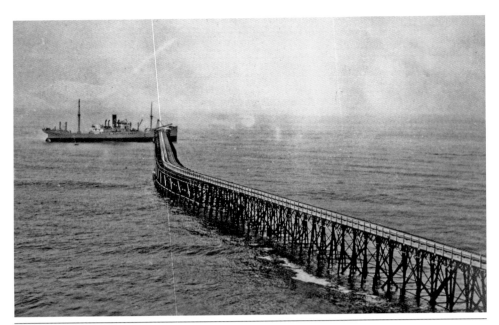

A 2,600-foot-long pier was constructed in the late 1930s at Davenport in order to transport cement by sea. Wave damage to the pier during construction led the engineers to turn the outer end of the pier more northerly into the swell. The pier had two 12-inch diameter pipes for loading dry cement as well as a 3-inch line for water and 6-inch pipe for fuel oil. The SS *SantaCruzCement* tied up at the end of the pier (*c.* 1940s) was in service for a little over 15 years until wave conditions were deemed too dangerous to ship cement safely by sea. Wave impact over the past 50 years has progressively destroyed all but the four innermost concrete piles. (Above courtesy of Alverda Orlando.)

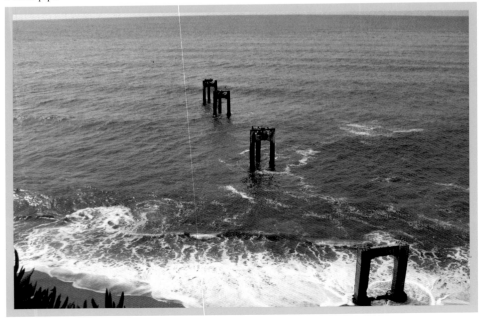

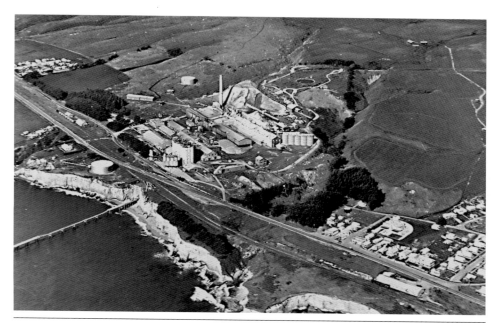

An aerial view of the coastline at Davenport (*c.* 1950) shows the old pier extending out into the ocean. A tunnel was excavated and extended from the cement plant, under Highway 1, where it emerged at the cliff face. The metal doors can still be seen today on the cliff face. The dangers of tying up to the pier and loading cement under high wave and wind conditions ultimately led to the end of transport of cement by sea in about 1955, when the outer section of the pier collapsed during a storm. Today the pier is gone, the oil storage tank on the cliff top has been removed as the plant now uses coal, and the cement plant has been expanded and modernized. The cliff continues to gradually retreat. (Above courtesy of Alverda Orlando.)

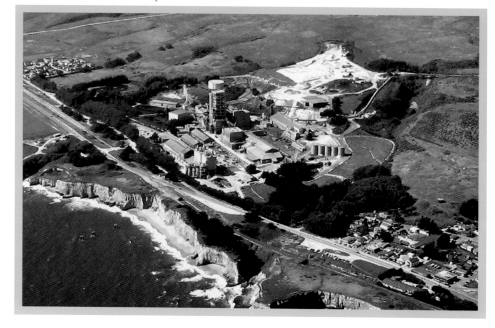

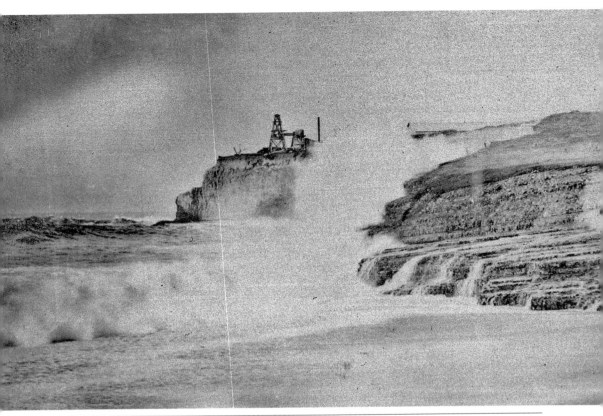

Visible on the cliff top in the distance of the 1905 photograph above is a derrick that was used to haul sand from the beach at the base of the cliffs to mix in with cement to make concrete for the actual construction of the cement plant. While the low bluff in the foreground has receded under wave attack, the cliffs below the old derrick have changed relatively little in the past century. (Above courtesy of Alverda Orlando.)

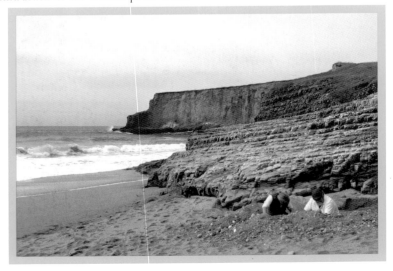

Davenport to Natural Bridges State Beach

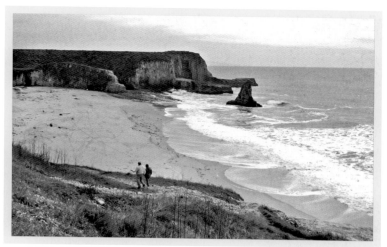

Sentinel Rock has been a landmark on the beach across Highway 1 and the small north coast town of Davenport for many years. The cliffs and Sentinel Rock consist of a geological formation known as the Santa Cruz Mudstone, a rock that is generally quite resistant to wave erosion. As a result, the cliffs in this area erode quite slowly. These photographs span a period of about 50 years and show almost no recognizable change. (Below courtesy of Special Collections, University Library, University of California Santa Cruz.)

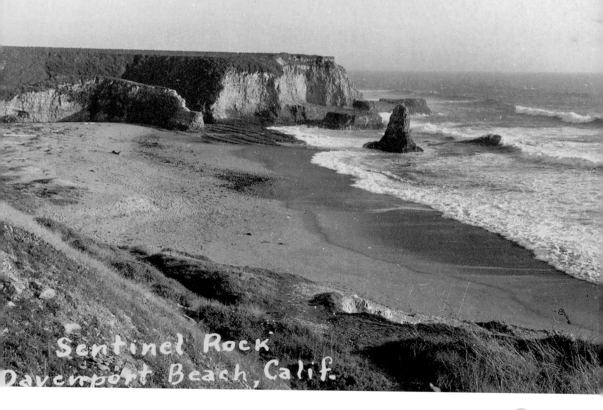

Sentinel Rock
Davenport Beach, Calif.

Davenport Beach has undergone significant change over just the past 35 years. Until the early 1970s, the south end of the beach and the adjacent railroad embankment were used as the city dump. Residents would drive alongside the railroad tracks and dump their trash down the embankment, where it would be periodically burned. In the distance on the far right side of the older photograph below (1969) is the remaining portion of the cement plant pier. The portion of the pier visible in this photograph is now completely gone. The cliff profiles on both sides of the photograph, however, have changed very little in the subsequent 37 years.

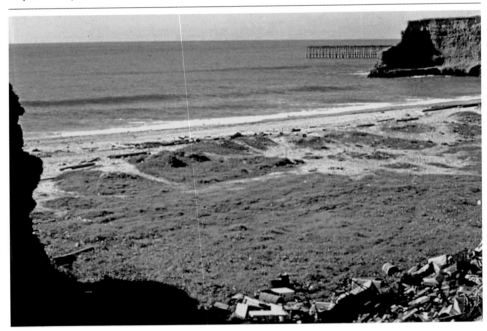

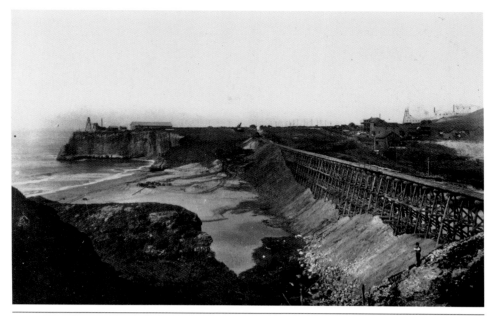

Before the current highway and railroad were built, the journey up the north coast in 1880 was very difficult, as travelers had to cross each of the steep, heavily vegetated canyons. In order to build an embankment for the railroad, a trestle was first constructed and then rock and earth from the cuts was carried out across the trestle by train and dumped over it to gradually form the structure. This 1906 photograph shows the finished trestle spanning San Vicente Creek south of Davenport, and the embankment that is slowly being formed. The timber trestle is still buried under the embankment today. The derrick is visible in the distance, and this point has eroded only slightly over the past 100 years, although the promontory at the far end of Davenport Beach has noticeably retreated. (Above courtesy of Sandy Lydon.)

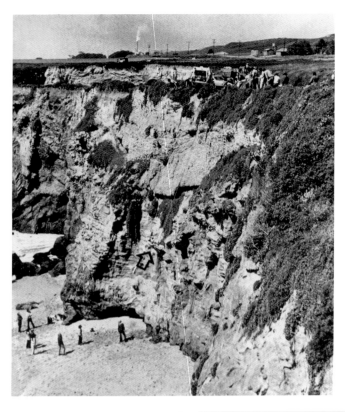

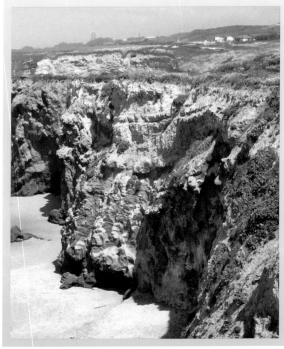

On this stretch of the north coast, hikers, fishermen and sightseers frequently find themselves in extreme danger, caught on the narrow beaches of the north coast at high tide or washed off the rocks by waves. The community of Davenport has maintained a volunteer rescue group that is often called to help out or search for stranded beachgoers. In this *c.* 1970 photograph taken at Yellow Bank or Panther Beach, 1.5 miles south of Davenport, the rescue team is practicing a rescue and hauling a stretcher up the cliff from the beach below. The name Yellow Bank comes from the orange sandstone cliffs, and the name Panther is derived from the weathering of the cliff rocks that has produced a cat-like shape on the cliff above the beach. (Above courtesy of Alverda Orlando.)

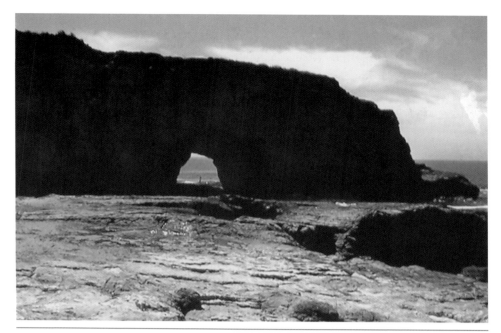

At Yellow Bank or Panther Beach, 1.5 miles south of Davenport, a small arch was present at the south end of the beach in 1978 where waves had eroded through a weak rock layer at the base of a promontory. Less than 20 years later, in 1995, the arch had completely collapsed. In contrast to the preceding La Niña–dominated years, the period from 1978 to 1998 was an El Niño–dominated era characterized by more frequent storms and more intense wave attack, which led to greater sea cliff erosion and retreat. In the 2006 photograph below, a large gap has opened up between the cliff and the seastack.

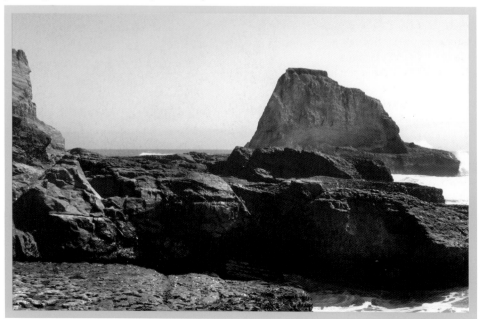

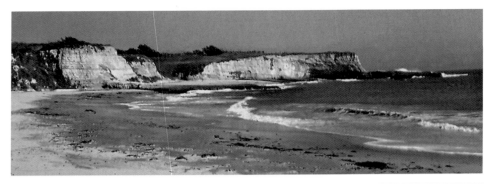

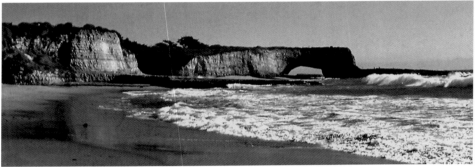

Coastal change can occur very slowly or very rapidly, depending upon the strength or weakness of the rocks making up the cliffs and also the intensity and frequency of large storm waves. Much of the significant erosion along the Santa Cruz coast has historically occurred during times when large waves arrived during very high tides. In the oldest photograph (1969) on this page, there is only a narrow promontory at the south end of Four-Mile Beach (a surfing break four miles north of the Santa Cruz city limits). By 1987, when the second photograph was taken, an arch had formed through wave erosion of a weak layer at the base of the cliff, and by 1995 the arch had totally collapsed. The most recent photograph was taken in 2006.

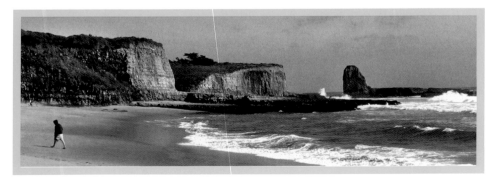

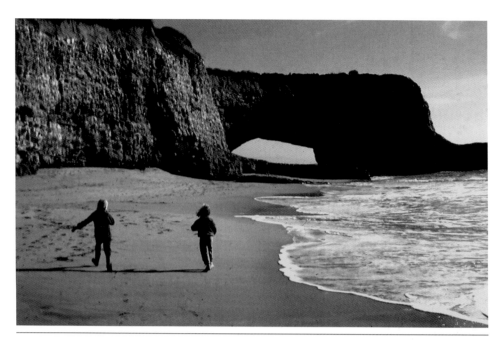

This pair of close-up photographs of the same arch at the south end of Four-Mile Beach spans only 20 years (1986 above, 2006 below) and demonstrates how rapidly coastal change can occur when arches collapse overnight.

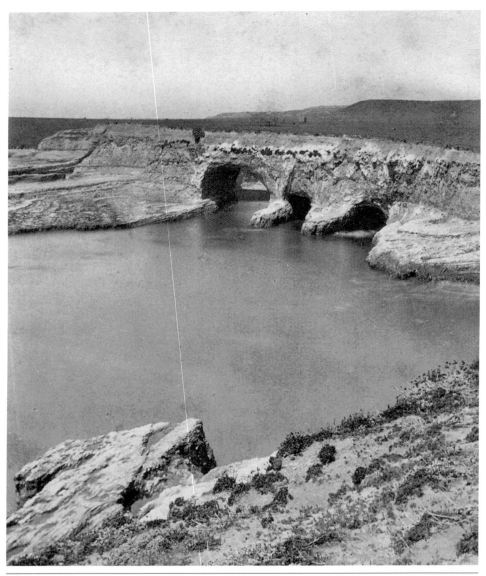

These three photographs show how the Wilder Ranch natural bridge changed over time, as seen from the terrace to the south. Initially (c. 1900) there was a single arch, and two caves eroded into the mudstone bedrock. Over time, the waves continued to erode both the sides of the arch and also the roof. In the span of time between the 1920 photograph (opposite above) and the 2006 photograph (opposite below), the arch continued to expand and finally collapsed and coalesced with the adjacent cave on the right. The pedestal that supported the right side of the arch is still

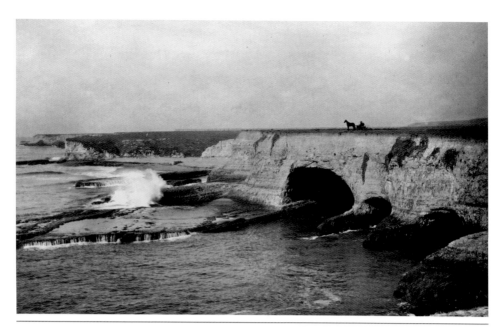

visible in the surf zone. The broad low mudstone shelf immediately to the left (north) of the arch is very resistant to wave attack and has changed little over 85 years. Harbor seals are often seen on this low shelf. (Opposite courtesy of Special Collections, University Library, University of California Santa Cruz; above courtesy of Santa Cruz City–County Library System.)

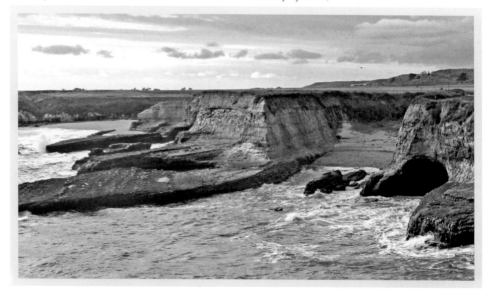

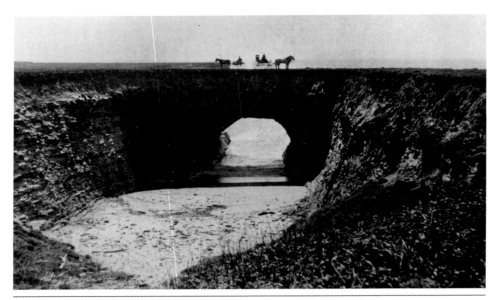

The Wilder Ranch natural arch, pictured from the north, was strong enough *c.* 1900 to support two horse-drawn buggies. The gradual erosion of the mudstone cliffs through constant wave attack finally removed the arch sometime between 1928 and 1943. For years, this beach was used as the dump for the ranch, and small pieces of wave-worn glass of different colors from the old dump are still found on the adjacent beaches. After Wilder Ranch became a state park in the 1980s, the dump was cleaned up. (Above courtesy of Special Collections, University Library, University of California Santa Cruz.)

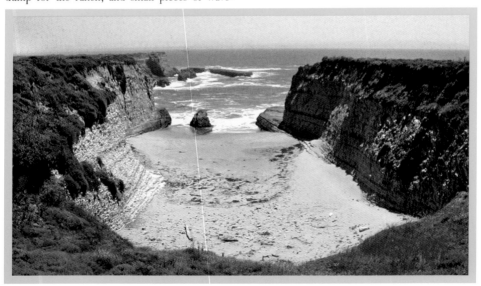

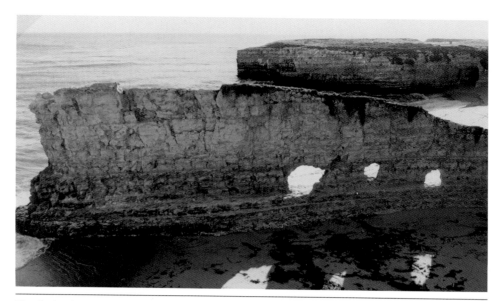

This bedrock pedestal at Younger Lagoon beach, next to Long Marine Laboratory, was unique in having three windows or small arches, well above beach level, that had formed from wave attack of a weak layer in the mudstone. During the winter of 1992, the right side of the pedestal completely collapsed due to wave impact. (Above courtesy of University of California Santa Cruz, Long Marine Laboratory.)

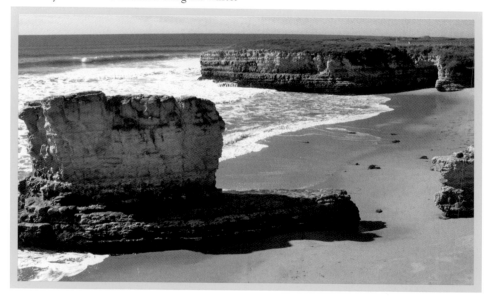

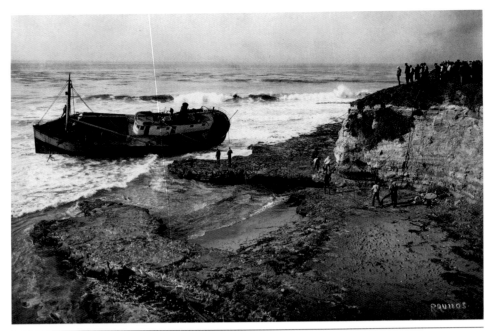

On October 1, 1924, turbulent seas forced the *La Feliz*, a small coastal vessel, onto the rocks just north of Natural Bridges. Local residents came to the site with automobiles and used their headlights to illuminate the ship and rescue the entire crew of 13. Salvaged and propped against the cliff, the mast was utilized in conjunction with ropes to recover equipment from the ship as well as the cargo of cases of sardines. Because of the protection provided from wave attack by the very resistant intertidal bedrock platform, the cliffs have remained stable over the years. Neither the cliff nor the bedrock platform has significantly changed in the subsequent 82 years. Amazingly, the mast of the *La Feliz* is still present today, leaning against the cliff. (Below courtesy of Santa Cruz Museum of Natural History.)

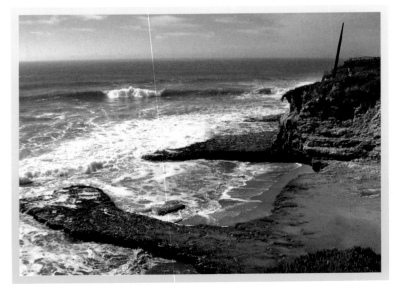

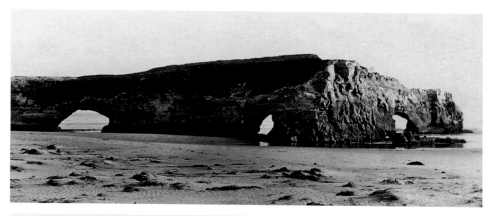

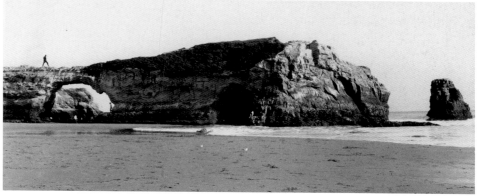

The natural bridges that were common along the coastline along West Cliff Drive from Natural Bridges State Beach to Lighthouse Point have been an attraction for visitors and residents alike for over a century. Natural Bridges (which was previously known as Moore's Beach, Hall's Beach, and Swanton Beach) has probably been the most widely visited and photographed site. Richard Harrison Hall, who came from Vermont to Santa Cruz in 1853, bought 300 acres out on the Cliff Road, which included Hall's Beach and three natural bridges (above, c. 1890). As the cliffs have been pounded by waves over the years, the bridges have progressively collapsed until only a single arch remains in 2006 (below). (Above courtesy Special Collections, University Library, University of California Santa Cruz; center courtesy of Rogers E. Johnson.)

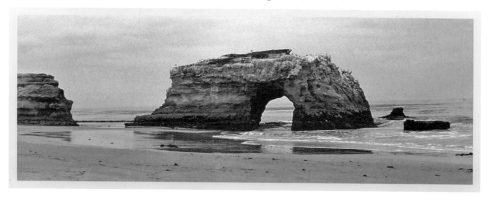

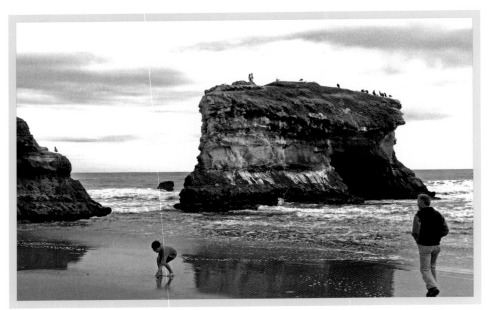

The arch closest to the coastline at Natural Bridges, pictured *c.* 1900 below, was easy to reach and commonly photographed. This arch survived for at least 125 years, as it continued to thin and weaken. It finally collapsed during a storm on the night of January 10, 1980. The outermost bridge was still intact in the fall of 1905 but may have collapsed that winter or shortly thereafter. The rock visible through the arch is part of the base of the outermost arch, and it continues to be reduced in size by wave action. (Below courtesy of Special Collections, University Library, University of California Santa Cruz.)

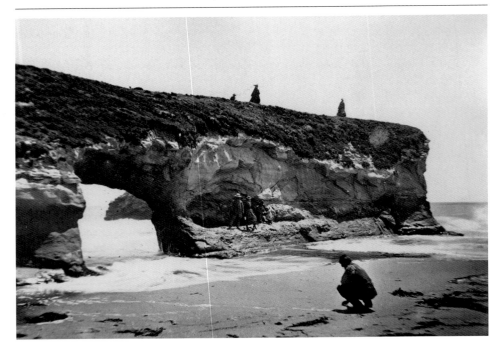

CHAPTER 2

WEST CLIFF DRIVE

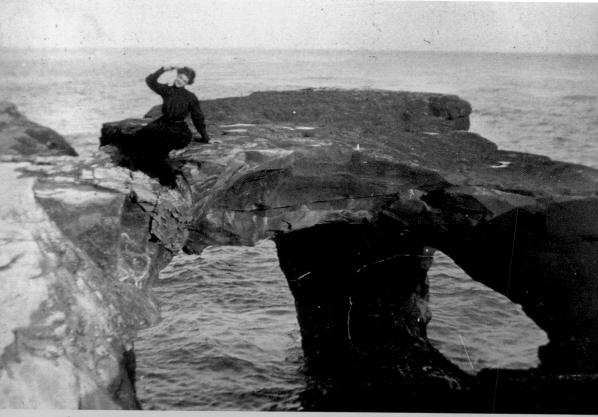

The wave-swept coastline along West Cliff with its natural arches and bridges has been a popular place for visitors and residents for over a century. Being photographed next to or on top of one of the many natural arches was something almost every visitor had to do. This unusual triple arch (c. 1910) that existed near the end of Woodrow Avenue (formerly Garfield) was a common site for photographs about the turn of the century, although there is no evidence left today to indicate precisely where this unique feature actually was. (Courtesy of Edie Rittenhouse.)

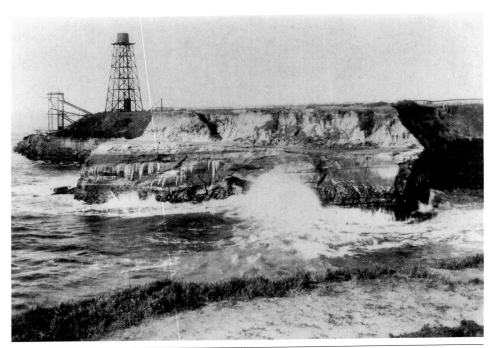

In 1898, the Armstrong brothers used some family ingenuity to solve the problem of excessive dust on the local wagon road along the coast. Following the 1897–1898 drought, tourists who came to Santa Cruz were faced with clouds of choking dust as they took their scenic drives along the cliffs near the lighthouse. The brothers drilled two shafts in the cliff and used a 600-pound piston to capture wave energy to pump seawater into a storage tank on the cliff. Water was then piped into horse-drawn water tanks that were used to water down the coastal wagon road. The section of mudstone cliff pictured here is very hard and has changed little in the past 100 years. One of the circular shafts where the piston was emplaced is still visible from the bicycle path along West Cliff although a concrete plug was recently placed over the shaft for safety reasons. (Above courtesy of the Harold J. van Gorder Collection.)

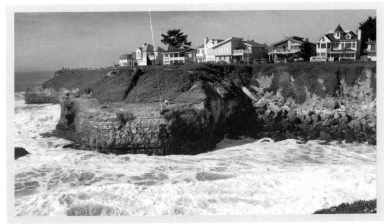

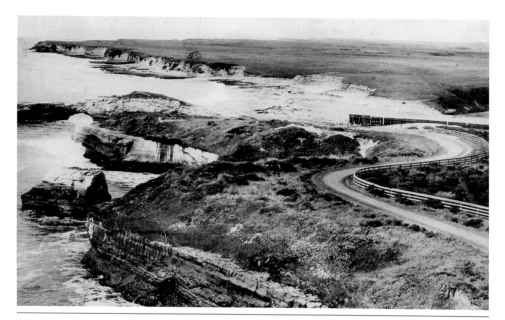

This unique perspective of the end of West Cliff Drive looking up the coast was obtained from the top of the wave motor tower *c.* 1900. West Cliff was a dirt wagon road, and it appears that there was a sand fence along the bluffs at Natural Bridges, probably to keep the sand from blowing onto the road. The north coast beyond what was then Hall's Beach is open terrace without trees or any development. Today the De Anza Mobile Home Park and Long Marine Laboratory occupy the coastal terrace. (Above courtesy of Special Collections, University Library, University of California Santa Cruz; below courtesy of Ken and Gabrielle Adelman.)

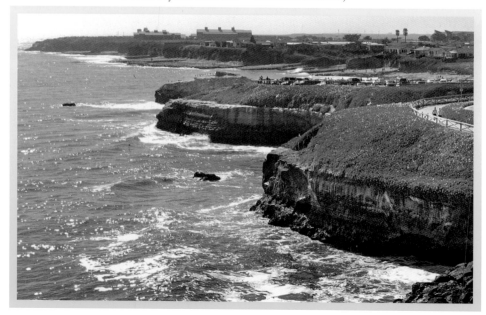

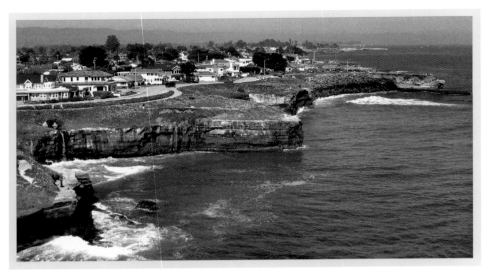

A look east toward Lighthouse Point from the top of the tower at the wave motor shows that, *c.* 1900 (below), the coastal terrace in the foreground and near distance was completely devoid of any vegetation but low grasses, the way it looked when the Spaniards arrived in 1769. The line of trees is close to Almar Avenue, which was about the edge of any development at that time. The point in the middle distance is at the end of Stockton Avenue. (Below courtesy of Special Collections, University Library, University of California Santa Cruz.)

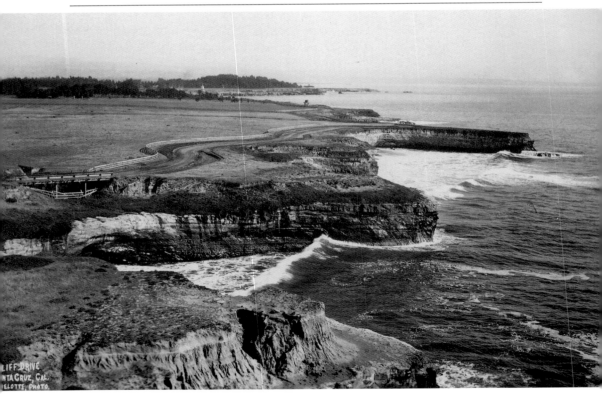

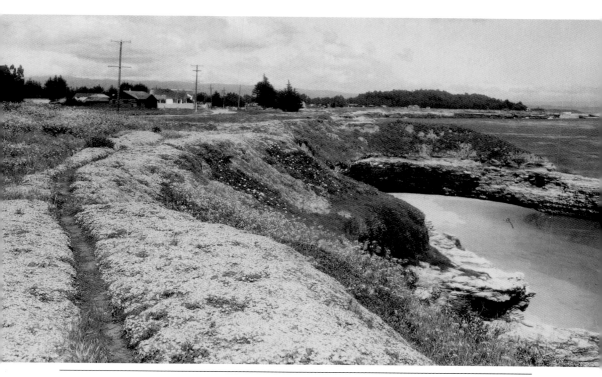

The low mudstone cliffs along West Cliff Drive at the foot of John Street are quite resistant to wave erosion and have changed little between 1950 and 2006. Note the extensive tree cover in the right background in the Lighthouse Field area, which was part of the landscaping of the James Phelan estate. Only a few of these trees remain today. (Above courtesy of Special Collections, University Library, University of California Santa Cruz.)

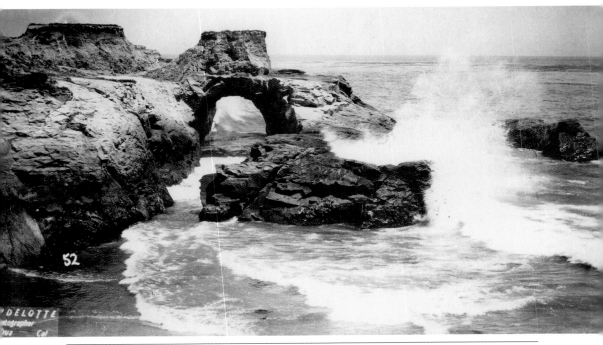

This picturesque natural arch, located below the Vue de L'eau streetcar station, was the site of many photographs and postcards in the late 1800s and early 1900s. Due to the orientation of joints or fractures in the siltstone and mudstone bedrock (the Purisima Formation), wave erosion created a series of parallel resistant promontories extending out into the surf zone, and the arch bridged two of these promontories. The arch was also known as Crown Arch, as the terrace deposits that existed for a time on top of the arch gave it the appearance of a crown. (Both courtesy of Special Collections, University Library, University of California Santa Cruz.)

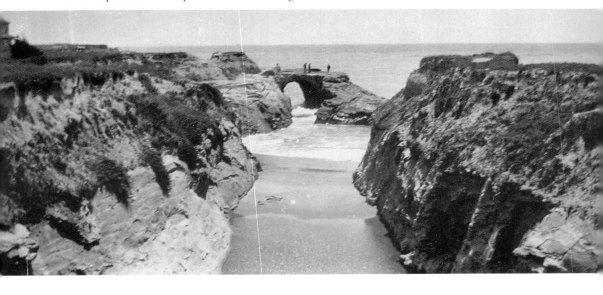

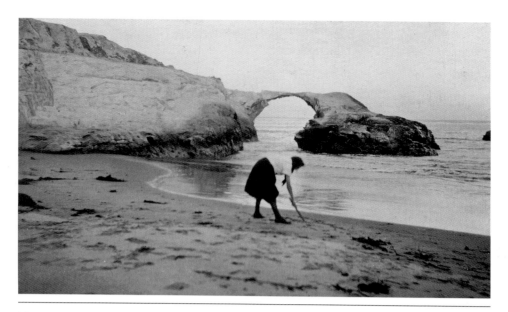

The wave erosion that created the arch also led to its progressive thinning and ultimate collapse sometime in the 1920s. Crown Arch may have also been the site of the triple arch shown in the first photograph in this chapter. (Above courtesy of Special Collections, University Library, University of California Santa Cruz.)

The Vue de L'eau streetcar station was located on the marine terrace at the end of Garfield Avenue (now Woodrow Avenue) and was built by the Santa Cruz, Garfield Park & Capitola Electric Railway in 1891 as an observatory, cliff house, waiting station and depot. This picturesque Victorian pavilion burned down in August 1925. In the 84 years since the photograph below (c. 1920) was taken, the edge of low cliffs have been cut back and the overlying terrace sands and soils have eroded back to West Cliff Drive by wave overtopping. Riprap has also been emplaced in an attempt to halt further bluff top erosion. (Below courtesy of Special Collections, University Library, University of California Santa Cruz.)

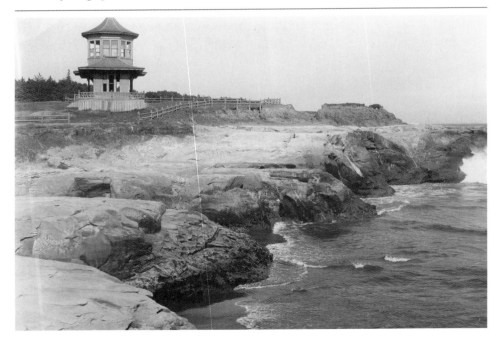

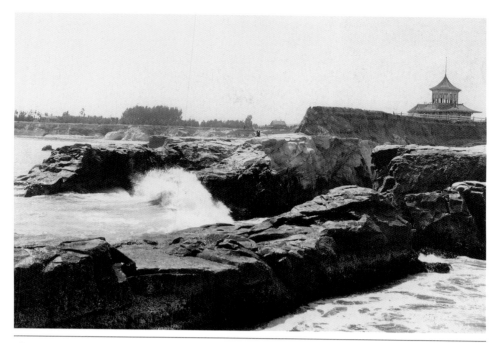

These parallel resistant rock promontories extended into the surf zone just below the site of the Vue de L'eau streetcar station (*c.* 1920). In 1905, the Norris and Rowe circus bought Vue de L'eau and the six acres surrounding it for use as winter quarters. For a while, there was also a marine museum across West Cliff Drive. This is the same area where Crown Arch used to span two of these promontories, which have been eroded back by wave action in the subsequent 86 years. (Above courtesy of Special Collections, University Library, University of California Santa Cruz.)

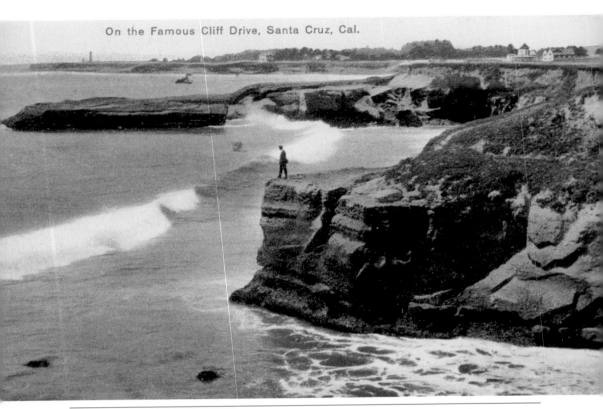

On the Famous Cliff Drive, Santa Cruz, Cal.

Bird Rock, as it is known today (because it is often covered with pelicans and cormorants), was originally a resistant point that extended a considerable distance into the surf zone and had a large arch when photographed in 1909 (above). The water tower of the Armstrong brothers' wave motor is visible on the horizon on the left side of the photograph. An early visitor stands on another promontory a few hundred feet to the east. The arch had collapsed by the late 1920s, splitting the point into two separate rocks. In the second photograph (opposite above), taken in 2005, the promontory where the man was standing has become an isolated sea stack. During the storms of late 2005, much of the remaining stack collapsed, leaving just a narrow spire (opposite below). (Above courtesy of Frank Perry.)

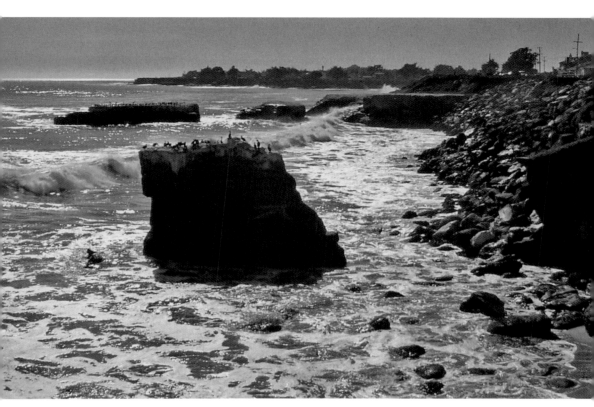

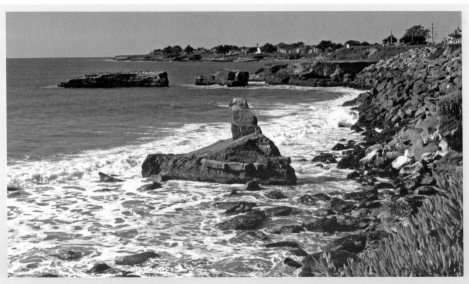

WEST CLIFF DRIVE

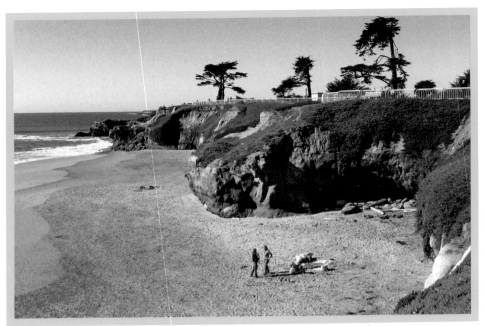

The low siltstone cliffs at Lighthouse Beach (known as "It's Beach" today) have changed very little in the 82 years between 1924 (below) and 2006 (above). The sea stack known as "The Old Shoe," pictured just offshore in 1924, has disappeared almost completely, although the low rock platform marking its location can still be seen at very low tides. Most of the trees planted in what was formerly called Phelan Park (now Lighthouse Field) have also disappeared over the subsequent 82 years. (Above courtesy of Special Collections, University Library, University of California Santa Cruz.)

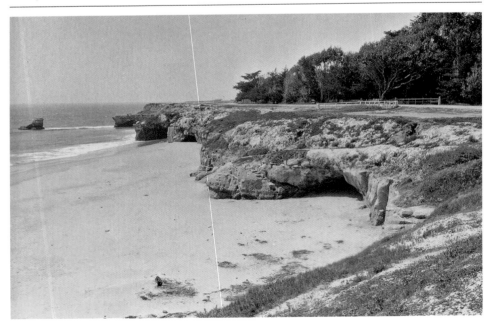

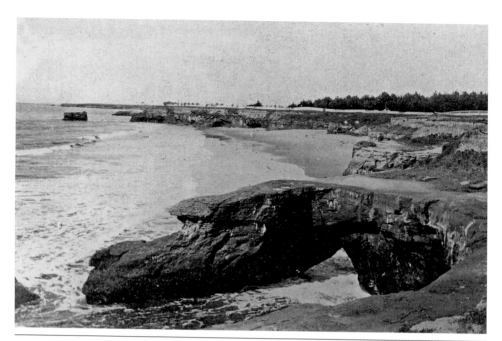

In the 1888 view of Lighthouse Beach above, an arch exists just north of Lighthouse Point. The sea-stack that was to become "The Old Shoe" is visible just offshore on the left. Lighthouse Field (known as Phelan Park at that time) was covered with trees, although there were only a few trees in the distance further out on West Cliff. In the 2006 photograph, the arch and The Old Shoe are both gone. Today there are many more trees in the distance and only a few left at Lighthouse Field. (Above courtesy of Special Collections, University Library, University of California Santa Cruz.)

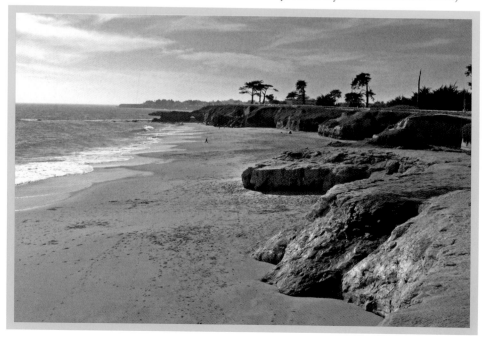

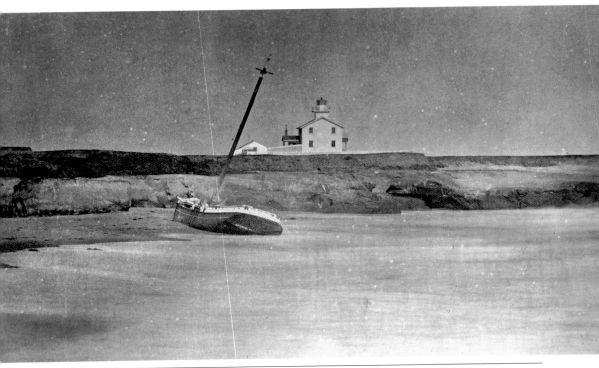

This small boat was grounded on Lighthouse Beach in October 1876. The *Active* had loaded railroad ties from the wharf in the morning and set sail at 8:00 p.m., but the wind died and left her about one mile from the lighthouse. The wind came up again later in the evening, and the crew was attempting to get underway when she was struck by a heavy sea and, even with two anchors out, she was washed onto the beach. In the morning, a line was thrown from the cliff below the lighthouse to the vessel. The crew used this line to work their way ashore, hand over hand. The original lighthouse, built in 1869, can be seen on Lighthouse Point. Over a century later, the low cliffs exhibit relatively little recognizable change, although caves under the point continue to erode. (Above courtesy of Santa Cruz Museum of Natural History, Hecox Collection.)

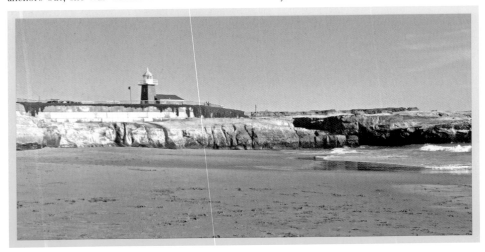

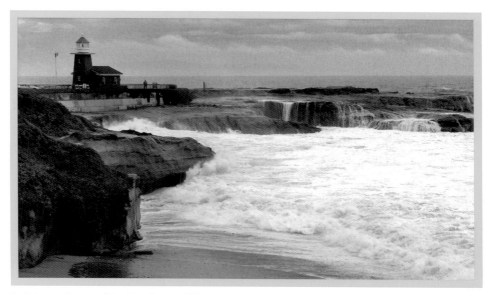

Lighthouse Point and Seal Rock just offshore owe their continued existence to erosion-resistant siltstone and mudstone, which has survived the intense wave energy that has always been focused on this area. Beneath the point, however, caves are being eroded and collapse still does occur. The *c.* 1890 photograph below shows an early visitor in a horse and buggy at about the present location of the lighthouse. As the current photograph above shows, the low cliffs continued to erode and retreat, but very slowly. (Below courtesy of Special Collections, University Library, University of California Santa Cruz.)

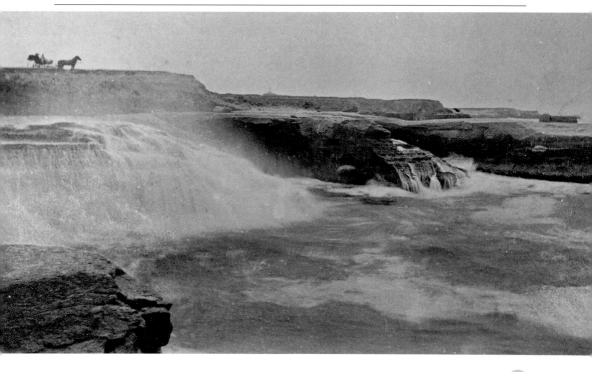

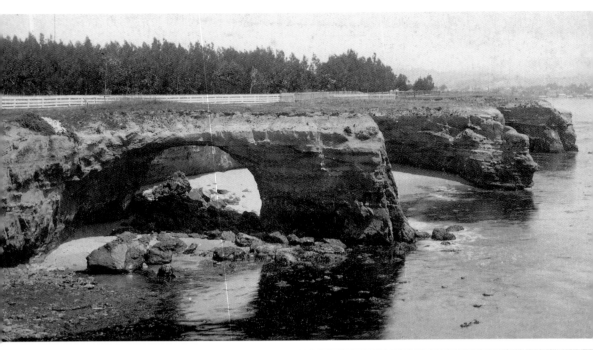

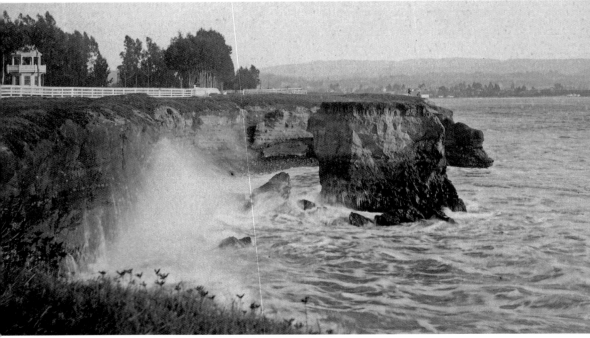

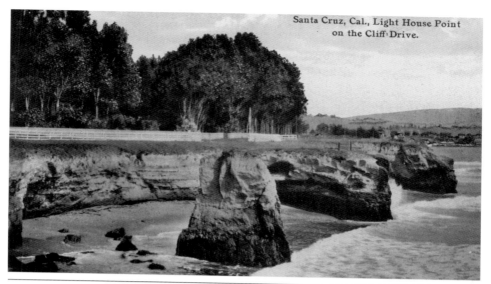

Santa Cruz, Cal., Light House Point on the Cliff Drive.

This series of photographs of Steamer Lane span almost 120 years. With time and continued wave attack, old arches expand and ultimately collapse, and new ones form. The same wave impact that creates the arches also gradually leads to their destruction. The first photograph was taken before 1888, and the second photograph (*c.* 1890) was taken shortly after the arch collapsed. Part of the arch can be seen in the surf zone. In the third image, (*c.* 1920) the fallen rock has been gradually worn down and broken up, just as the base of the arch in the 2006 photograph continues to be lowered by winter wave attack. (Both opposite courtesy of Special Collections, University Library, University of California Santa Cruz; above courtesy of Frank Perry.)

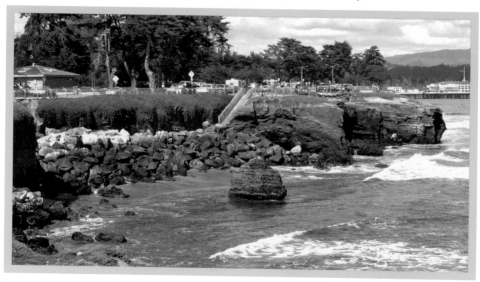

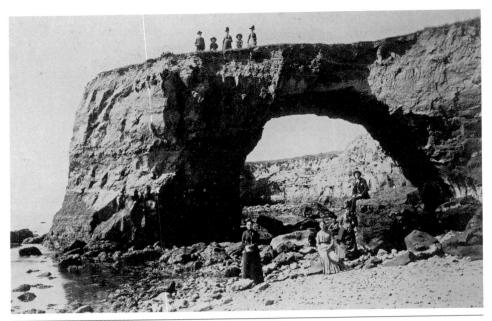

This arch at Steamer Lane was a favorite location for photographs until it collapsed during a storm in 1888. The West Cliff area continues to erode as winter waves break against the cliffs at high tide. Natural arches and bridges such as this are common due to the nearly horizontally bedded sedimentary rocks that make up the coastline in this area. As waves erode weak layers or along fractures at the base of the cliff, caves or undercuts are created. Where these occur along a resistant headland or point, they may eventually meet to form a natural arch. (Above courtesy of Special Collections, University Library, University of California Santa Cruz.)

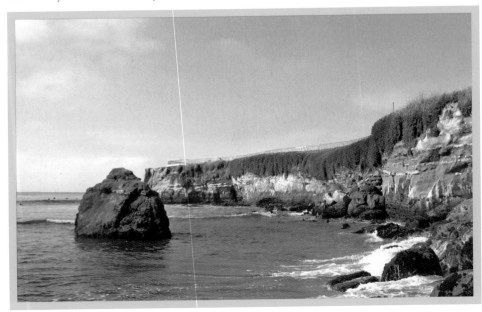

CHAPTER

3

COWELL'S BEACH
AND THE BOARDWALK

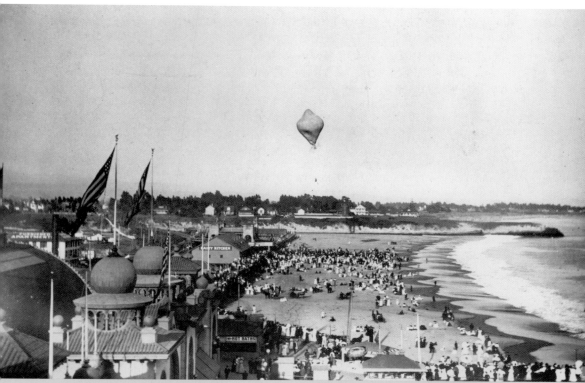

Events such as this balloon ascension were staged on the Main Beach to draw large crowds during the summer months and were the brainchild of entrepreneur and promoter Fred Swanton. He was the driving force behind the first casino built on the beachfront in 1904. The casino was destroyed in a fire in June 1906, but Swanton quickly rebuilt it in time for the 1907 summer season. His influence in the early 20th century was so strong that Santa Cruz was often referred to as "Swantacruz." (Courtesy of the Museum of Art and History at the McPherson Center.)

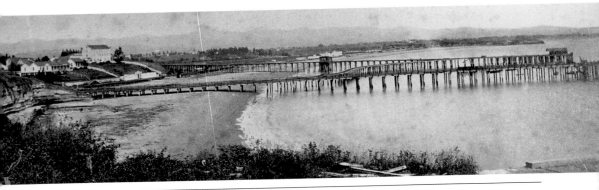

The Santa Cruz Beach area has seen a complex series of piers built for different purposes over 150 years. Before the construction of the first structure (called a chute) in 1853, lumber, produce, and passengers had to travel through the surf in small boats to ships waiting offshore. The wharf in the foreground was constructed in 1857 by David Gharky and was located just west of the present-day Municipal Wharf. In 1875, the wharf was completely rebuilt and tracks laid to its end by the Santa Cruz and Felton Railroad. Known locally as the Railroad Wharf, freight and passengers used this wharf until the present-day Municipal Wharf eclipsed it in 1914. The railroad wharf was subsequently torn down in 1922. In the background of the first photograph (c. 1880) is the wharf, built in 1864 by the California Powder Works, the first blasting and gunpowder manufacturing plant west of the Mississippi River.

Located along the San Lorenzo River two miles north of Santa Cruz, the powder company shipped nitrate in from South America and blasting powder out. The wharf extended seaward from Beach Hill at the intersection of Second and Main streets. Known locally as the Powder Company Wharf, between 1877 and 1882 the structure was connected to the Railroad Wharf by a cross wharf. Both the Powder Company Wharf and cross wharf were dismantled in 1883, as most of the powder mill products were now being shipped by railroad. The low white building on the beach on the left side of the above right photograph (c. 1890) was a bathhouse and had a sign painted on the front that stated, "No Sharks Here." (Above courtesy of the Harold J. van Gorder Collection; opposite above courtesy of the Museum of Art and History at the McPherson Center.)

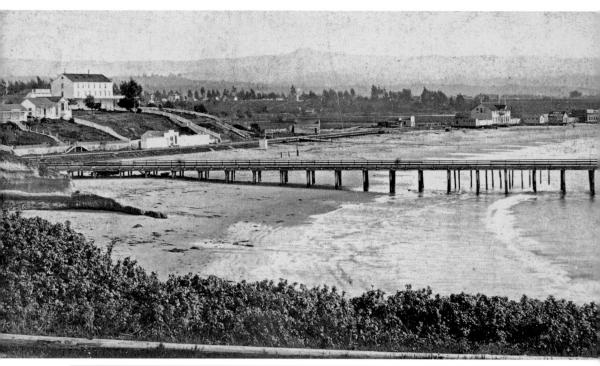

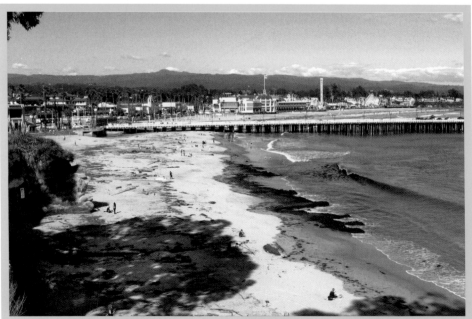

COWELL'S BEACH AND THE BOARDWALK

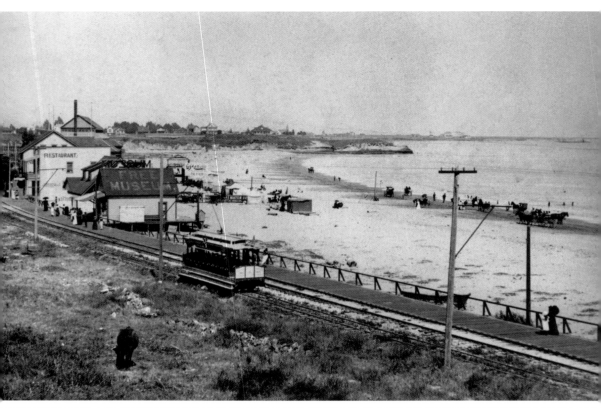

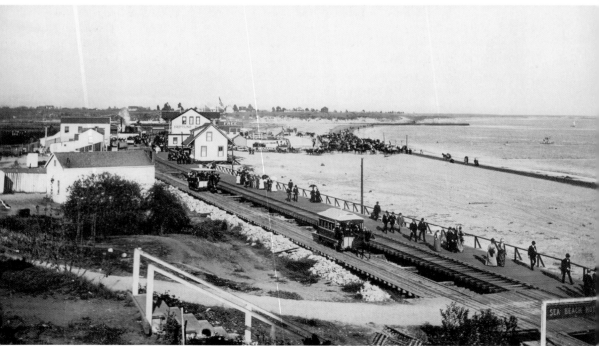

COWELL'S BEACH AND THE BOARDWALK

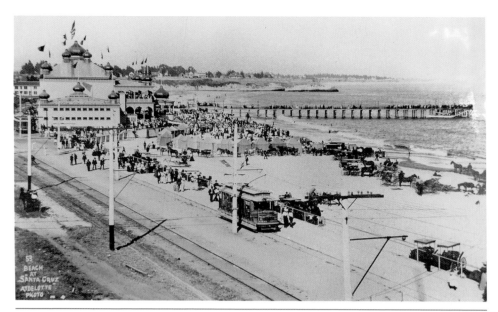

The beachfront of Santa Cruz was initially fronted by a boardwalk and horse-drawn trolley (c. 1885). Signs on two buildings can be made out: "Free Museum" and "Restaurant," about where the western end of the Boardwalk would be today. In the second photograph (c. 1893), electric streetcars have replaced horses but horse-drawn buggies are still seen along the beach. By the time the third photograph was taken in the summer of 1905, the first casino and the Pleasure Pier were built, and the beach was covered with horses and buggies. San Lorenzo Point, adjacent to the mouth of the San Lorenzo River, is visible in the distance in all of the photographs and does not appear to have changed significantly over this 120-year period. The older photographs were all taken from the old Sea Beach Hotel, which no longer provides this photographic perspective of the main beach. (Both opposite courtesy of Special Collections, University Library, University of California Santa Cruz; above courtesy of Covello and Covello Photography and the Harold J. van Gorder Collection.)

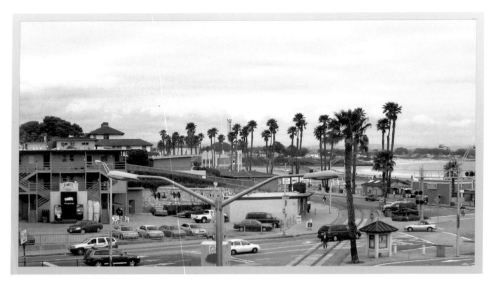

The 1880s photograph below was taken from the old Howe truss bridge and shows the end of a train on the right heading out onto the Railroad Wharf. This track is crossed by the railroad that passes under the truss bridge and toward Nearys Lagoon. Just to the left of the center of the photograph is the Sea Beach Hotel. (Below courtesy of Santa Cruz City–County Library System.)

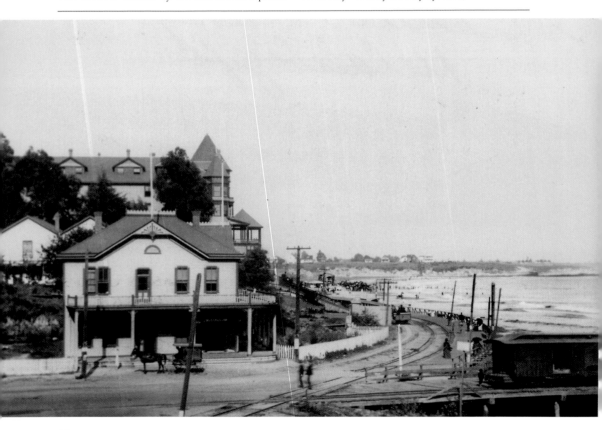

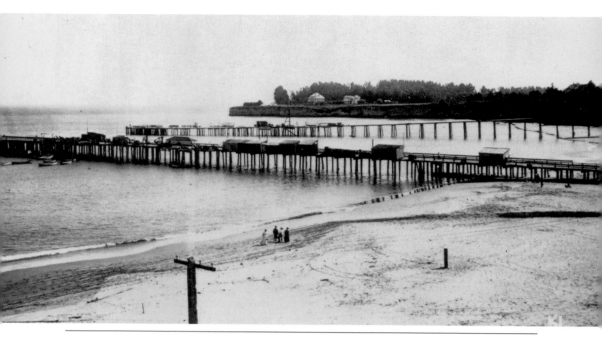

The Railroad Wharf in the foreground (*c.* 1900) started between the current pier and the Santa Cruz Coast Hotel, where the public beach parking lot is located today. The Cowell wharf, which is in the distance, was at a much higher elevation as it left the cliffs at the end of Bay Street, between where the Sea and Sand Motel and the Santa Cruz Coast Hotel are now. (Above courtesy of Santa Cruz Museum of Natural History.)

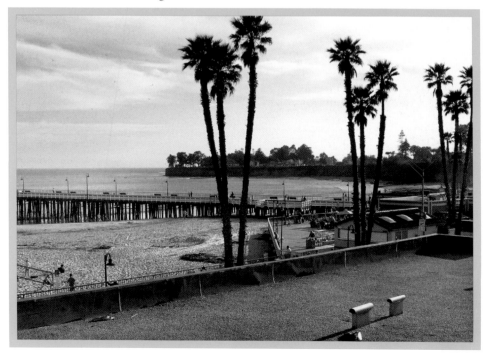

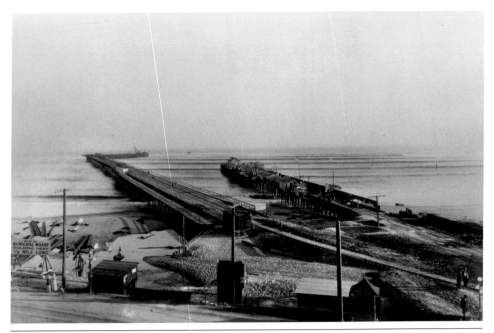

The older Railroad Wharf is to the right, and the newer Santa Cruz Municipal Wharf, built in 1914, is to the left. The sign on the lower left reads, "New Municipal Wharf Building Here. 1/2 Mile Long." Once the new wharf was constructed, the railroad lines were shifted to the Municipal Wharf. The Italian fishermen continued using the Railroad Wharf as their base of operations (note all of the small buildings on the Railroad Wharf) but moved to the Municipal Wharf when it was completed. After serving the area for 57 years, the Railroad Wharf was finally demolished in 1923. (Above courtesy of Santa Cruz City–County Library System.)

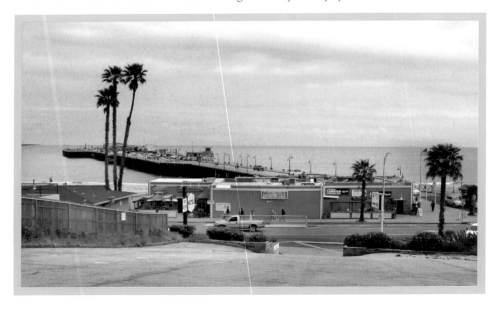

The Sea Beach Hotel (pictured *c.* 1910 below) was expanded from the smaller preexisting Douglas House and opened in 1888 but burned down in 1912. On top of the hill in the distance, above the Railroad Wharf, is the Sedgewick Lynch House, built in 1877, which survives to this day. Sedgewick Lynch arrived in California by steamer in 1849. After prospecting for gold in the Sierra and indulging in many other adventures in the West, he settled in Santa Cruz and became a general contractor, building wharves (including the original Soquel Wharf), railroads, and other buildings. The family home at 170 West Cliff Drive is now a historic landmark and, when built, was the second largest house in Santa Cruz at a cost of $12,000. (Below courtesy of the Harold J. van Gorder Collection.)

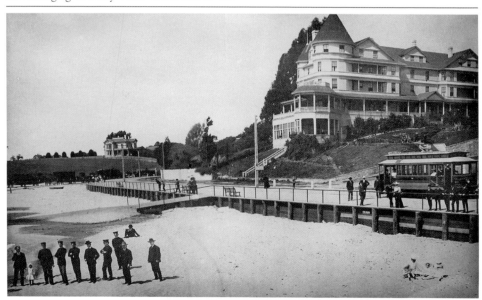

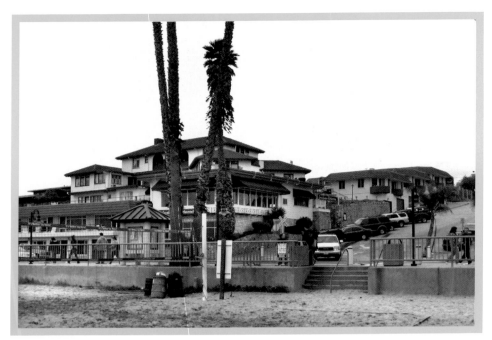

The Sea Beach Hotel (1885) was a major landmark along the Main Beach in Santa Cruz for nearly 25 years and was known nationally as one of the great hotels on the Pacific Coast. D. K. Abeel, a newspaper publisher from Kansas City, bought the original Douglas House in 1887 and made it the nucleus around which he built and developed the 170-room Sea Beach. When it burned down in 1912, it ended an era of elegance and high society for Santa Cruz tourism. (Below courtesy of Santa Cruz City–County Library System.)

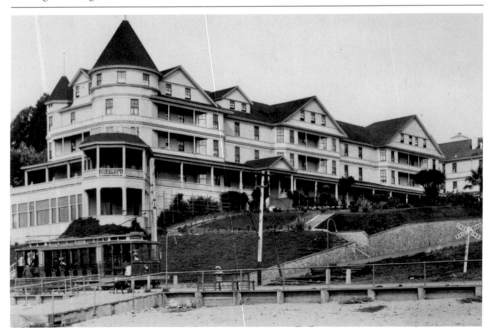

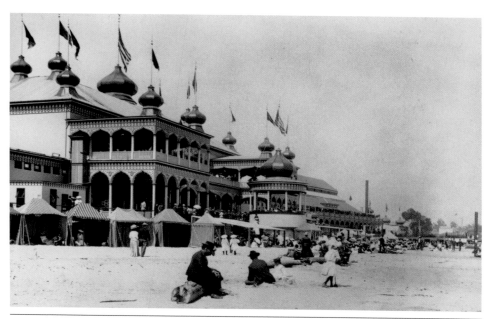

To many visitors, the Boardwalk and Main Beach area has been, and still is, Santa Cruz. This beachfront area was the focal point for visitors as early as the 1860s, and in 1867 the *Santa Cruz Sentinel* announced the presence of "a dwelling house for the accommodation of bathers on the beach." A year later, John Liebrandt built a bathhouse, swimming tank, and entertainment house there. Capt. C. F. Miller opened the Neptune Baths in 1884, which was so successful that he added 50 additional rooms the next year. In 1893, Miller and Liebrandt joined forces and built a bathhouse with an indoor seawater pool in the beachfront area. Then the entire beachfront image changed with the arrival of an energetic and imaginative entrepreneur, Fred Swanton, in 1903, when he and partner John Martin bought out Miller and Liebrandt and formed the Santa Cruz Beach, Cottage, and Tent City Corporation. In 1904, they opened the brightly colored, Moorish-inspired, Neptune casino along what is now Beach Street. Two years later, this ornate and uninsured structure burned to the ground at a loss of $500,000. Before the smoke had settled, Swanton convinced his partner Martin to put up $1 million and rebuild the casino. On June 15, 1907, it opened on schedule with great fanfare. (Above courtesy of Covello and Covello Photography.)

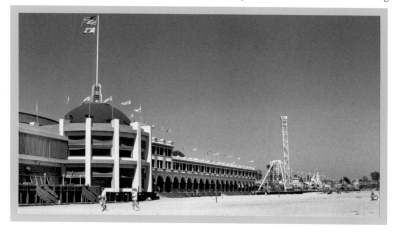

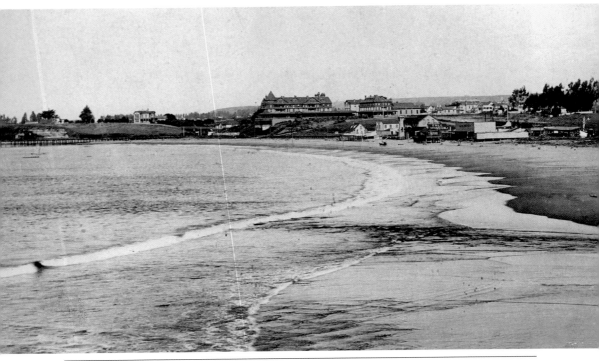

The skyline of the Main Beach-Boardwalk has changed completely since the above photograph was taken in 1887. Other than the beach itself, the only structure in the photograph remaining today is the Sedgewick Lynch house, which sits on top of the hill on West Cliff Drive and is visible in the upper left portion of the photograph. The Municipal Wharf replaced the Railroad Wharf, the Casablanca replaced the Sea Beach Hotel, and the Boardwalk with the Big Dipper, the Logger's Revenge, and the Double Shot forming the skyline today has replaced the saltwater baths. (Above courtesy of Special Collections, University Library, University of California Santa Cruz.)

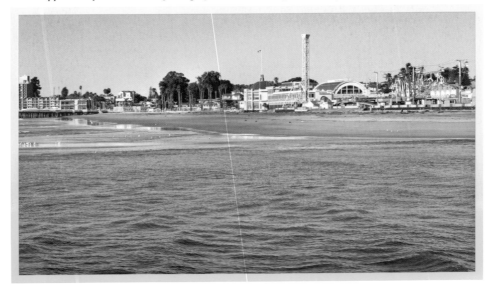

COWELL'S BEACH AND THE BOARDWALK

The mouth of the San Lorenzo River has remained in the same place for at least 150 years, although the means of crossing it have changed over time. In the *c.* 1890s photograph below, the railroad crosses the river on an elevated track and then a steel trestle. For years, a footbridge across the river connected the Seabright neighborhood with Santa Cruz. It was removed each fall, and when it was put away, the Seabright residents walked across the railroad bridge—a dangerous route—when they were in a hurry to get "to town." People also used rowboats and canoes to get across and up and down the river. (Below courtesy of Santa Cruz City–County Library System.)

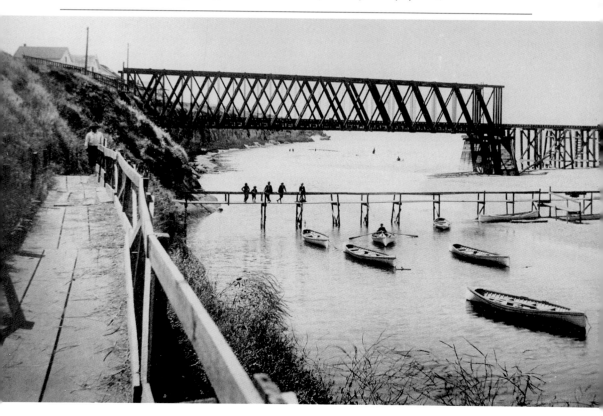

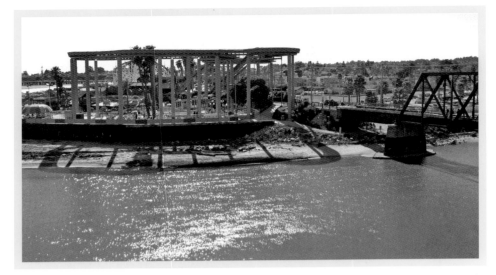

The photograph below was taken from the east bank of the San Lorenzo *c.* 1890 and shows a wide sandy beach and a low vegetated area of sand dunes where the Boardwalk exists today. The Beach Flats area is sparsely developed, and a few houses appear down on the beach where the Logger's Revenge is today. In the distance, the railroad wharf and the Sea Beach Hotel are visible, as well as the Lynch House on West Cliff above the wharf. (Below courtesy of Santa Cruz City–County Library System.)

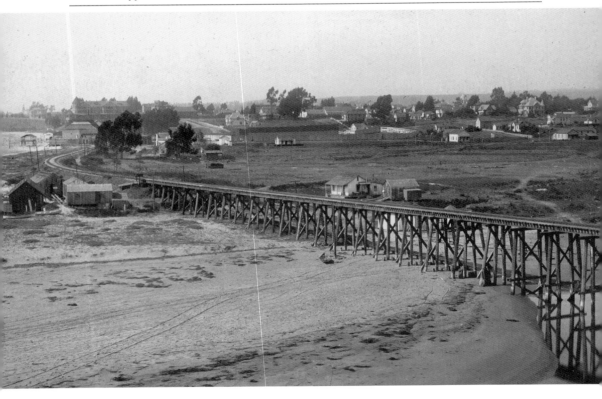

CHAPTER

4

SEABRIGHT BEACH TO PLEASURE POINT

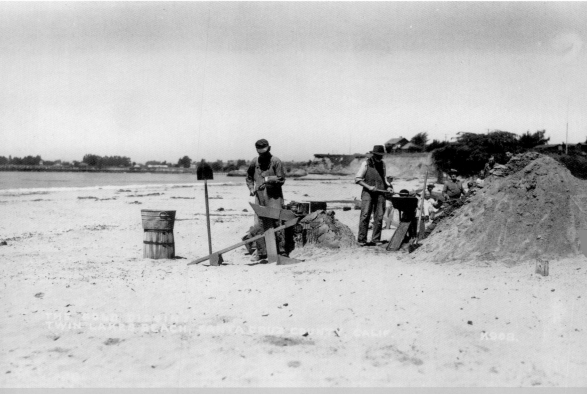

Most Santa Cruz beaches contain small amounts of dark or heavy minerals, such as magnetite, and sometimes even traces of gold can be found in the black sand. When the price of gold rose high enough, local miners would stake out mining claims on the beaches and make a few dollars from a lot of hard work. In this mid-1890s photograph, a group searches for gold in the sand on Seabright Beach. (Courtesy of Santa Cruz City–County Library System.)

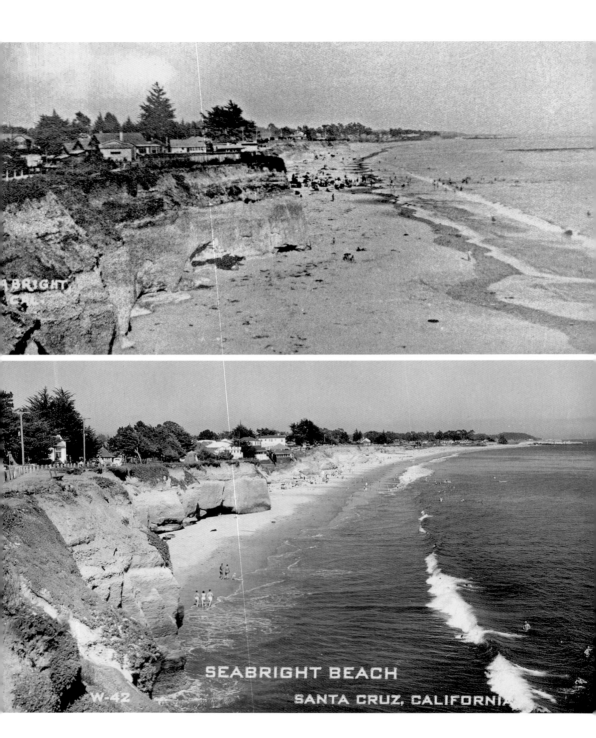

SEABRIGHT BEACH

W-42

SANTA CRUZ, CALIFORNIA

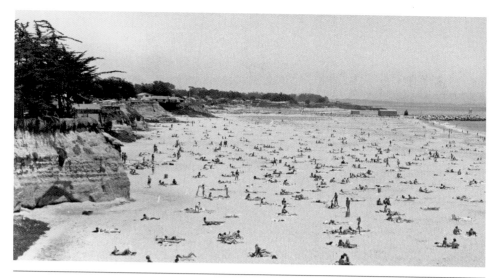

Seabright Beach has gone through significant changes over the past century as a result of human intervention. Prior to the construction of the Santa Cruz Small Craft Harbor jetties in 1962, the beach was relatively narrow in winter but wide enough during the summer months to be a popular recreational beach. In the summer, the narrow beach extended continuously from the river mouth at San Lorenzo Point, for nearly a mile to Black Point, which can be seen in the distance, in the upper right corner of the photographs. Once the west jetty was completed, however, sand being carried into the bay began to accumulate behind the jetty and formed a 500-foot-wide, year-round beach. (Opposite above courtesy of Special Collections, University Library, University of California Santa Cruz; opposite below courtesy of Frank Perry.)

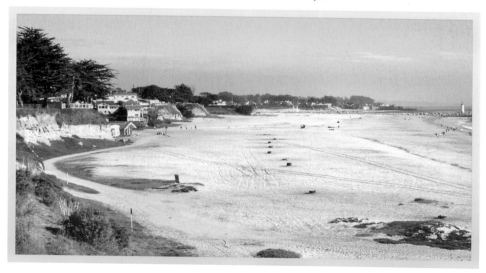

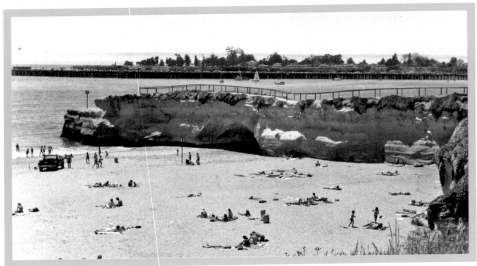

San Lorenzo Point is a resistant promontory consisting of sandstone and siltstone of the Purisima Formation, about three million to seven million years old. Generally, this type of geologic formation is relatively weak and susceptible to wave attack, but at this location, as well as at Lighthouse Point, it is quite hard. Both points have persisted for well over a century. When the photograph below was taken *c.* 1920, there was virtually no beach here. The 1977 photograph above shows that, with the completion of the Santa Cruz harbor in 1964, the sand backed up behind the west jetty and widened this beach considerably so that the waves no longer attack the bluffs. As the beach has widened and stabilized, permanent vegetation has been established on the back beach. The configuration of the point, however, has changed very little in 85 years. (Below courtesy of Special Collections, University Library, University of California Santa Cruz.)

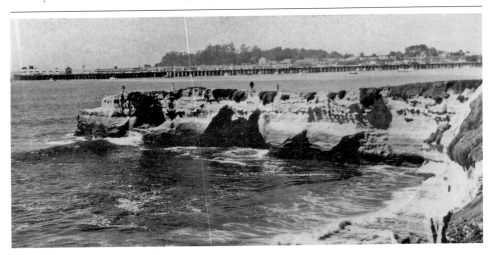

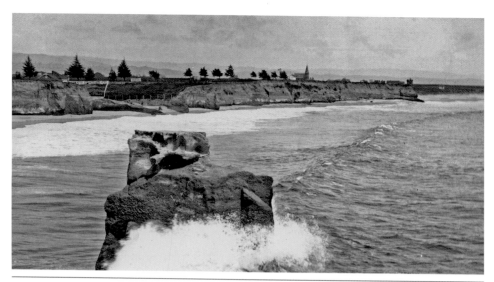

The rock or seastack just to the east of San Lorenzo Point was a fixture on the beach for at least a century but split and partially collapsed during the 1989 Loma Prieta earthquake. In the c. 1900 photograph above, there is almost no development on the bluffs. (Above courtesy of Special Collections, University Library, University of California Santa Cruz.)

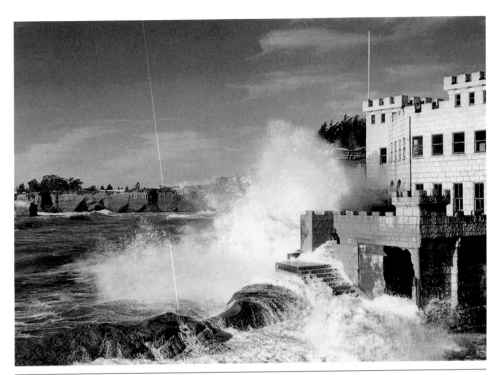

The old-timers in Santa Cruz knew Seabright Beach as Castle Beach. Built by James Pilkington around the turn of the last century, the castle on the right side of this 1953 photograph was used originally as a bathhouse. In 1918, Louis Scholl added a dining room and called it Scholl-Mar Castle. It served as a restaurant in the 1940s known as the Casa del Mar and then operated as an art gallery for a brief time in the 1950s and 1960s. In the years prior to the construction of the Santa Cruz Small Craft Harbor (1962–1964) and the subsequent formation of a wide Seabright Beach, the waves attacked the bluffs each winter and coastal erosion was an ongoing problem. The castle was demolished on March 24, 1967. (Above courtesy of Special Collections, University Library, University of California Santa Cruz.)

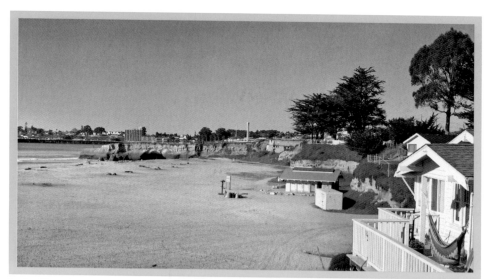

In the 2005 photograph above, the beach widening effect of harbor construction is evident. The house on the bluff top in the foreground is still present today, while the castle and rock point in front of the castle have been removed or completely eroded. Below, in a 1931 photograph of the castle (which was on the bluff directly across the street from where the Santa Cruz Museum of Natural History is located today), the lack of a permanent Seabright Beach is clearly evident, as waves attacked the bluffs and the castle most winters. (Below courtesy of Special Collections, University Library, University of California Santa Cruz.)

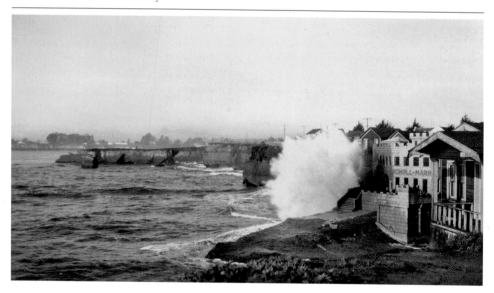

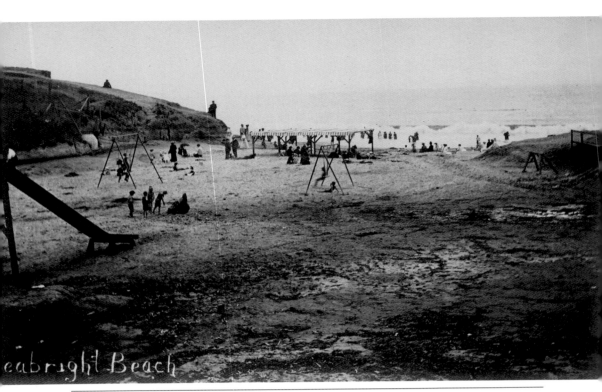

Seabright Beach

Seabright Cove (*c.* 1915), in front of the city Museum of Natural History, has been a popular beach for over 100 years. Before the harbor was built in the early 1960s, it was the only wide beach available for recreation, and this is where beachgoers congregated. In the *c.* 1920s photograph (opposite above), the Scholl-Mar Castle is visible on the right side of the cove. Today this cove serves more as an access way to the much larger and year-round Seabright Beach. (Above courtesy of Frank Perry; opposite above courtesy of Santa Cruz City–County Library System.)

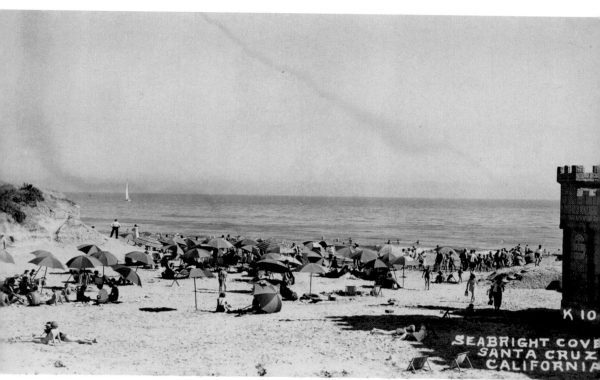

SEABRIGHT COVE
SANTA CRUZ
CALIFORNIA

K 10

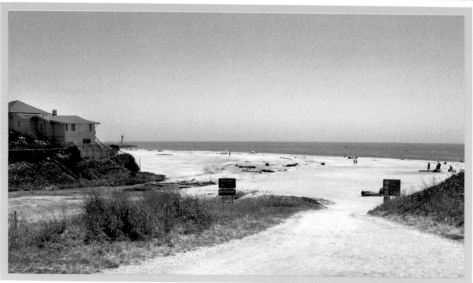

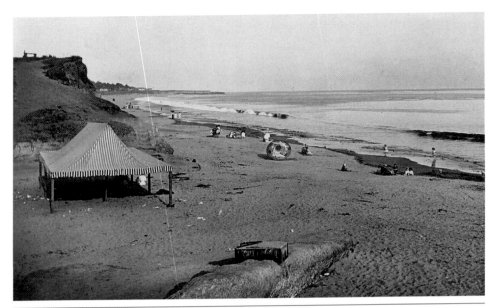

In the 1918 photograph above, taken from the Scholl-Mar Castle, the beach, while narrow, extends uninterrupted all the way to Black Point on the horizon. The coast is virtually undeveloped except for a few structures visible on the bluffs in the distance. In the 2004 photograph below, the beach is much wider as a result of the harbor jetties just down coast. The lighthouse is visible on the end of the west jetty. (Above courtesy of Special Collections, University Library, University of California Santa Cruz.)

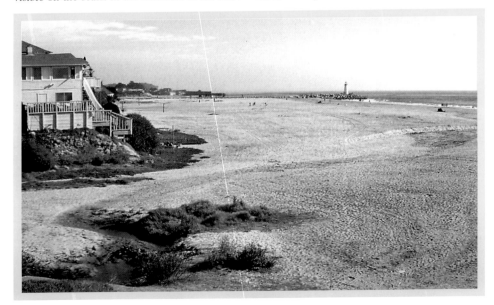

During the 1880s, there was a small settlement in the Seabright Cove area called Camp Alhambra. It was eventually renamed Seabright, after the town in New Jersey. The bridge across the small stream, Pilkington Gulch, was ultimately replaced by a culvert and fill, and until the harbor construction of the early 1960s that resulted in the widening of the beach, winter waves washed into this cove. One of the original houses from the photograph below (1891) with the two second-story gables is still present today, just to the right of the center of the photograph. The woman walking on the beach in the 1891 photograph is Miss Forbes, who always wore black and carried a cane or umbrella. (Below courtesy of Special Collections, University Library, University of California Santa Cruz.)

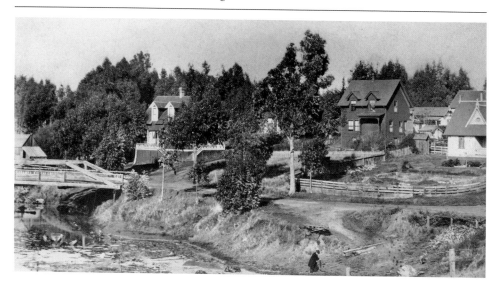

The Twin Lakes trestle over Schwan Lake in the *c.* 1910 photograph below was named for the pioneer Jacob Schwan family. Jacob was a native of Germany who built a house and farmed in the area in 1862. Schwan Lake, Woods Lagoon, and the area near them came to be known as Twin Lakes. The Santa Cruz small craft harbor was dredged out of the most westerly of the twin lakes (Woods Lagoon) between 1962 and 1964. (Above courtesy of University of California, Santa Cruz, Special Collections Library.)

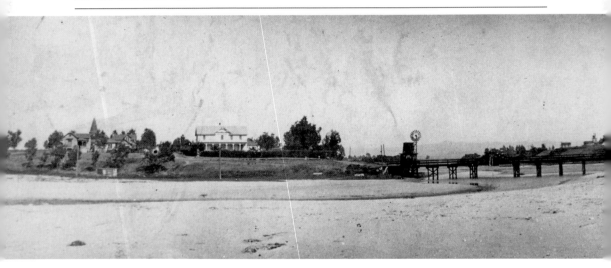

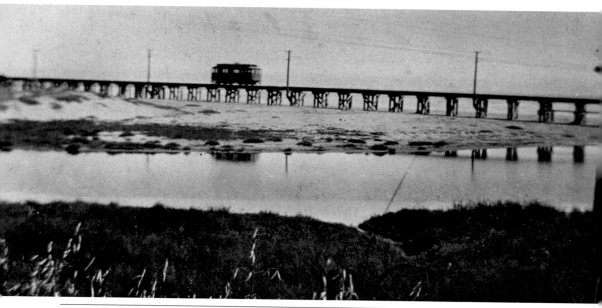

A streetcar line connected Capitola and Santa Cruz between 1905 and 1926. In the above photograph, a Union Traction streetcar heads westward, across the Twin Lakes trestle in front of Schwan Lake. The tracks were elevated well above beach level, so when the tracks reached the bluffs at Twelfth Avenue, they were at the height of the bluff top and the streetcar continued down Twelfth Avenue. The beach at this time was much wider and more stable than today, as indicated by the vegetated sand dunes on the left side of the photograph. Many of the original pilings are still visible today, a century later, during the winter months when the beach has been eroded by winter storms. (Above courtesy of Santa Cruz City–County Library System.)

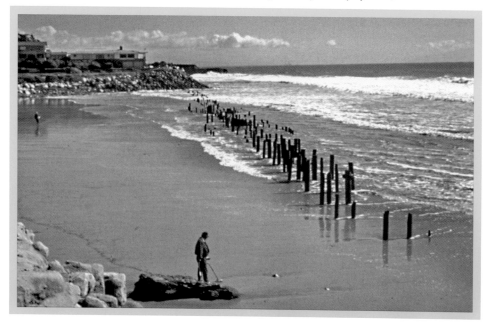

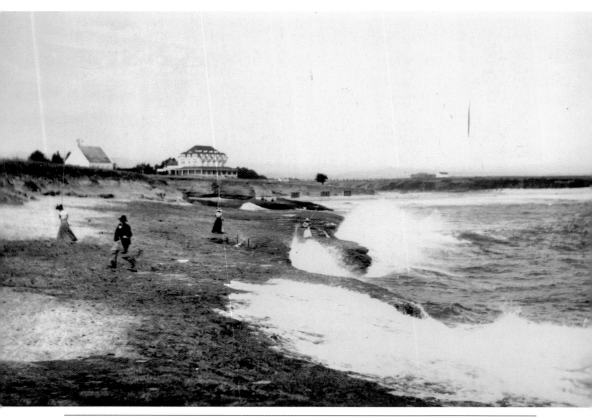

A low sandstone terrace has existed for years immediately west of Sunny Cove (*c.* 1910), which has been used by fishermen and local residents. In the 95 years between when these two photographs were taken, surprisingly little change has taken place to the terrace. The original Santa Maria del Mar Hotel is visible on the bluffs in the background. (Above courtesy of Santa Cruz Museum of Natural History.)

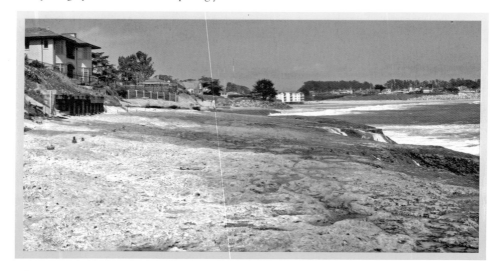

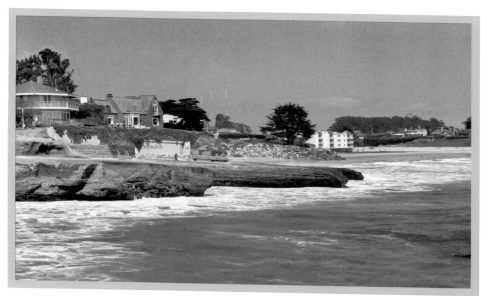

In April 1891, James Corcoran, Patrick Moran, and Henry Johans donated land along East Cliff near Nineteenth Avenue to the Catholic Ladies Aid Society to establish a resort for "Catholic women of restricted means." The three-story building in the background is the Santa Maria del Mar Hotel, later known as Villa Maria del Mar. To defray the costs of the building and grounds, the Hotel Maria del Mar was used a resort for paying guests during the summers. (Below courtesy of Frank Perry.)

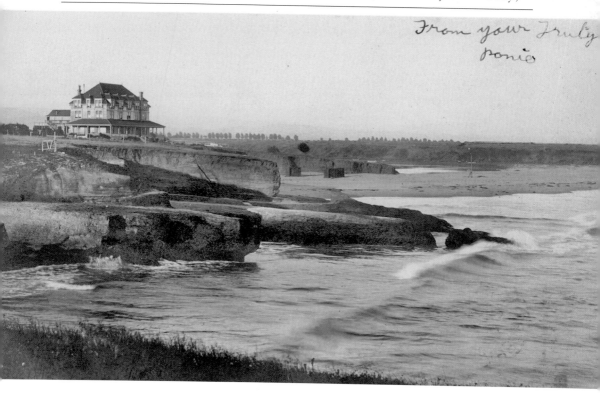

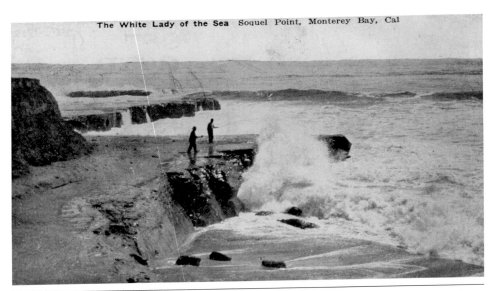

The White Lady of the Sea Soquel Point, Monterey Bay, Cal

Soquel or Pleasure Point is a resistant zone of Purisima Formation bedrock. Rockview Drive was probably named because of these rock exposures. While the underlying bedrock on which the fishermen are standing is quite resistant to wave attack, the overlying sands and gravels, or terrace deposits, are unconsolidated and far more erodible and have been stripped off by waves creating this flat bedrock terrace. (Above courtesy of Frank Perry.)

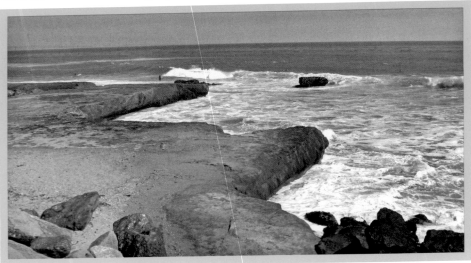

CAPITOLA TO RIO DEL MAR

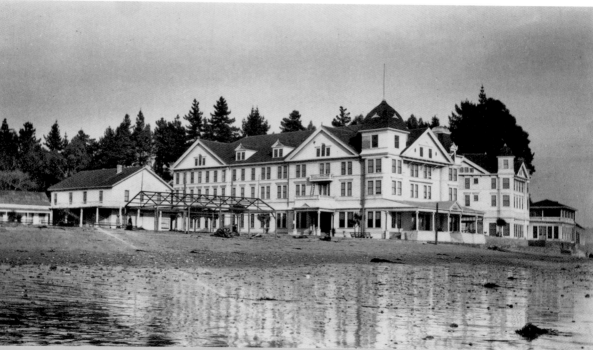

T. Frederick Hihn, Capitola's developer, oversaw construction of the 160-room Capitola Hotel, which was built between 1895 and 1897. It replaced the first hotel structures and a row of changing rooms below the bluff. In 1900, a one-week stay in the hotel, meals provided, cost from $10 to $12.50. Although elegant, the Capitola Hotel was regarded as outdated by the time it was destroyed by fire in 1929. Afterward, the site remained empty until 1935 when a ballroom was relocated here and joined with new resort structures. These buildings, remodeled into a wax museum and a nightclub, were lost during a second fire in 1957. (Courtesy of Santa Cruz Museum of Natural History.)

In the *c.* 1900 above view looking upcoast from the Opal Cliffs area, the coastal cliffs were almost completely undeveloped and there were only a few trees. Today the entire cliff top from Capitola to Santa Cruz is developed with expensive homes and many are threatened by erosion and retreat of the cliff edge due to constant wave attack. Many properties have now constructed seawalls or installed riprap to try to halt or slow cliff retreat. (Above courtesy of Special Collections, University Library, University of California Santa Cruz.)

Camp Capitola, founded by S. A. Hall, officially opened July 4, 1874. Hall, who leased the land to grow crops, opened the summer resort with permission from landowner Frederick Hihn, a prominent Santa Cruz businessman. In this *c.* 1888 photograph, the first homes are visible on what is now Depot Hill, which was subdivided with lots along Cliff Avenue in 1884. Hihn required that homes be set well back from the coastal bluff, so that it could be reserved for public paths and a park site. On the right side of the photograph are the first camp structures, including a 30-room hotel and annex. (Below courtesy of Santa Cruz Museum of Natural History.)

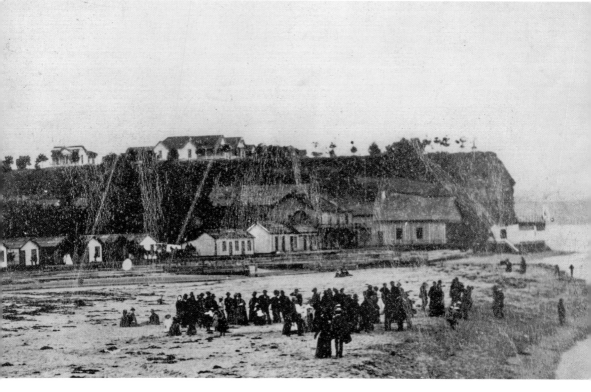

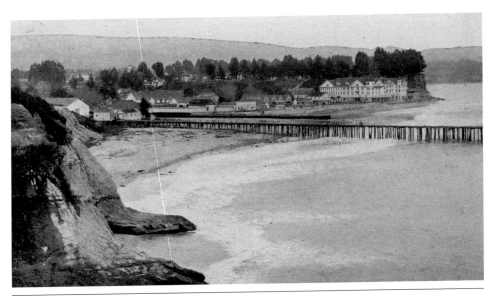

When Santa Cruz County was formed in 1850, this beach was a point known as La Playa de Soquel, and the flat was used for fishing, shipping, and agriculture. When Frederick Hihn acquired the land in 1857, he immediately initiated the construction of a 450-foot wharf for the transport of lumber and produce. The pier was subsequently lengthened to about 1,200 feet to accommodate larger ships. Soon damaged by large waves and often in need of repair, the pier has been rebuilt several times following storms in recent years as well. The oldest photograph (1911) shows the second Capitola Hotel, which was completed in 1897. Among the attractions for summer visitors were shooting and photo galleries, a bandstand, and a ballroom and skating rink (the large barn-like building clearly visible in the second photograph behind the derrick). While Depot Hill only had a few trees in the 1880s, by 1911 it was covered with trees. Three Victorian duplexes (The Six Sisters with peaked roofs) were built at the edge of the beach in 1903. The second photograph (c. 1924) shows Soquel Creek, dammed in the summer months for swimming by scraping sand from the beach to form a sandbar. (Above courtesy of Frank Perry; below courtesy of Special Collections, University Library, University of California Santa Cruz.)

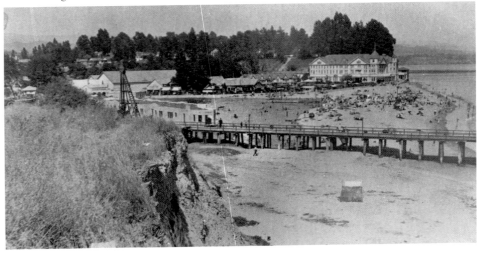

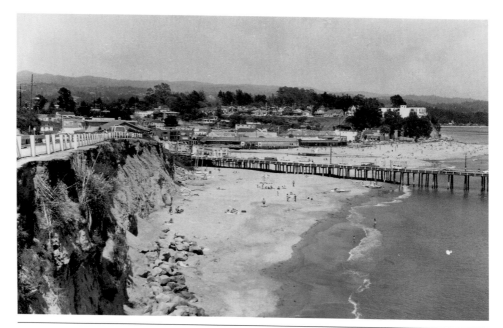

In the late 1960s, the beach at Capitola narrowed as sand moving down coast was trapped by the construction of the jetties at the Santa Cruz harbor (1962–1964). In an effort to regain the beach, which Capitola relied on for summer tourists, a 250-foot-long groin was constructed in 1969 and about 2,000 truckloads of local quarry sand were imported. A widened beach and the groin are visible beyond the pier in the 1977 and 2005 photographs. Riprap is also visible at the base of the cliff in the foreground, which has been added to over the years in an effort to protect East Cliff Drive.

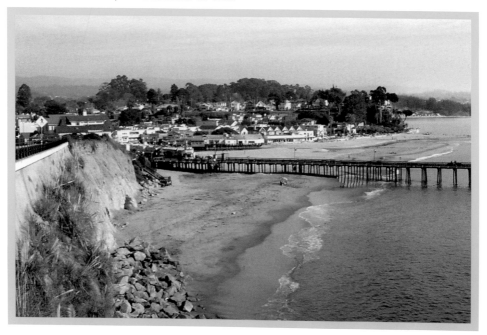

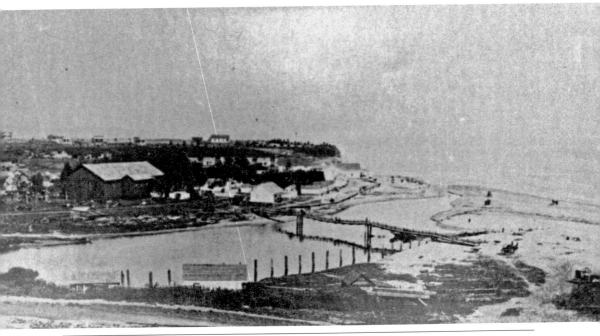

A pedestrian cable bridge spans Soquel Creek in the *c.* 1885 photograph above. The broad-gauge railroad runs along alongside Cliff Drive in the foreground with the railroad bridge across Soquel Creek, just upstream to the left of the photograph. No wagon bridge has yet been constructed. Shacks of the emergent fishing village are visible in the left foreground. The large building to the left of the footbridge is the skating rink and dance pavilion built by Frederick Hihn in 1884. (Above courtesy of Special Collections, University Library, University of California Santa Cruz.)

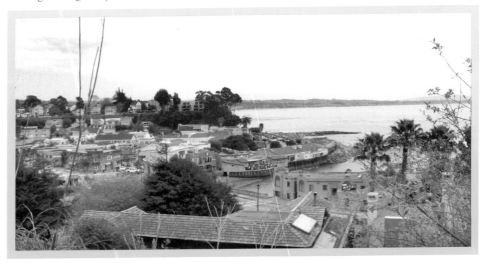

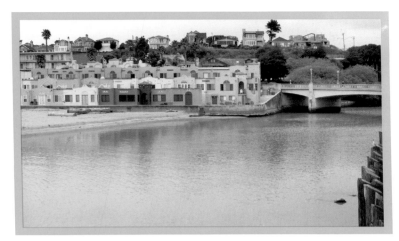

The *c.* 1890 photograph below was taken from the east side of Soquel Creek, looking toward the western bluff and a budding, but less successful resort called "Camp Fairview." A footbridge and the wagon bridge across the creek are visible on the right side of the photograph. The course of Soquel Creek has been redirected to enlarge the summer beach, and a boardwalk follows the bulkhead along the east side of the creek. The Venetian Courts were built beginning in 1923 on the beach on the site of the former fishing village. (Below courtesy of Santa Cruz City–County Library System.)

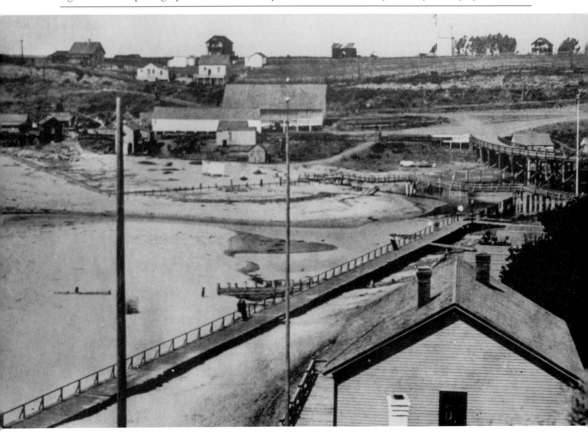

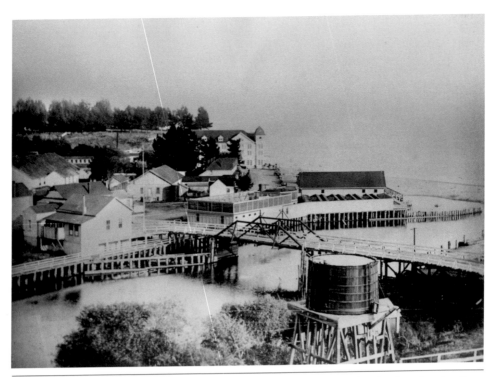

F. A. Hihn modernized Capitola in 1900. When the earliest photograph was taken about 1903, the hotel and new resort structures appeared along the esplanade and a sturdy wagon bridge crossed Soquel Creek near the location of the present Stockton Avenue Bridge. A year later, a third bridge was completed and an electric railway circulated through Capitola Village toward the hotel. Trolley service between Capitola and Santa Cruz continued until the automobile era began. The service ended in 1926, and the tracks were torn out soon afterwards. A timber bulkhead that

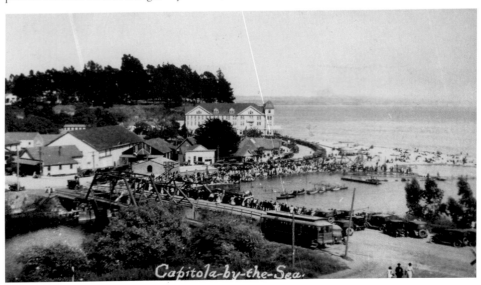

Capitola-by-the-Sea.

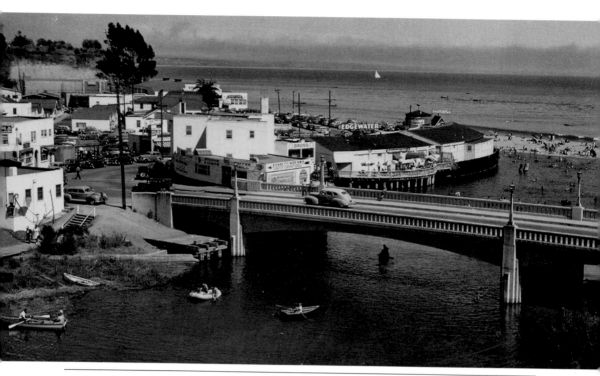

still exists today has controlled the east side of Soquel Creek. By the time the 1920 photograph was taken, the damming of the creek to form a lagoon was an annual tradition and both swimming and boating competitions were popular. The Capitola Hotel is visible below the cliffs in the distance in the two oldest photographs, although it burned down several years later in 1929. The c. 1950 photograph shows the concrete Stockton Avenue Bridge that replaced the old wagon bridge in 1934. (Both opposite courtesy of Santa Cruz City–County Library System; above courtesy of Frank Perry.)

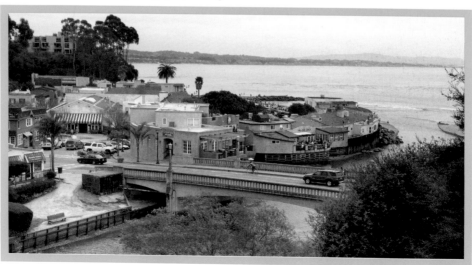

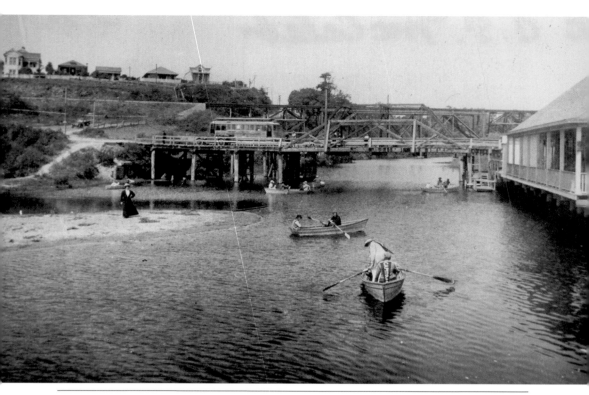

The Capitola Lagoon has been dammed up in the summer for many years for swimming and boating, and in this *c.* 1915 photograph several people are rowing boats in the lagoon alongside the bathhouse building. The wagon bridge is in the middle of the picture and further upstream and at a higher elevation is the railroad trestle. Some of the earliest houses are visible on the bluff above the railroad, which follows the same route today. The Venetian Courts were built out on the west side of the beach starting in 1923 and probably completed in 1924. (Above courtesy of Santa Cruz City–County Library System.)

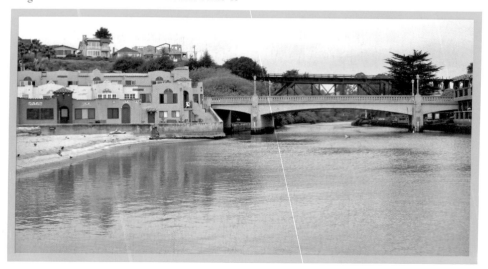

While Capitola beach (below, *c.* 1905) looked similar at the start of the 19th century as it does today, the surf bathers looked quite different. The typical bathing suits of the day were made of heavy wool, and propriety required that women wear several layers of clothing, as well as stockings. In the distance, toward the Capitola Hotel is the pole and rope that allowed novice bathers to enjoy the ocean, as few vacationers were good swimmers at this time. (Below courtesy of Santa Cruz City–County Library System.)

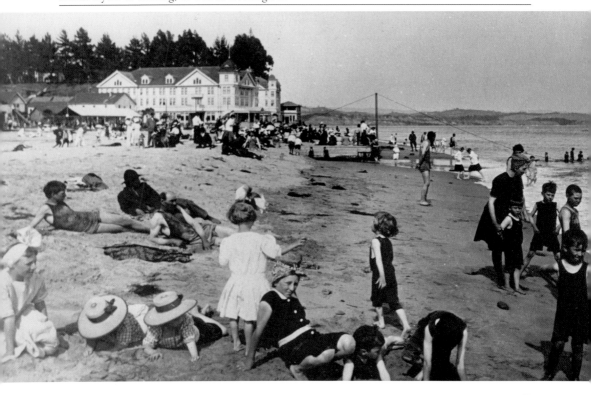

CAPITOLA TO RIO DEL MAR

Eli J. Wood and his son, Robert A. Wood, are delivering oak wood to the old Capitola Hotel in the 1902–1903 photograph below. The wagon is stopped in front of the Six Sisters, along Ocean Front Avenue (now the Esplanade). Soon after H. Allen Rispin purchased the Capitola Hotel from heirs of F. A. Hihn in 1919, he initiated a number of improvements for the resort. The trolley line was redirected to a new terminus, and the roadway along the beach was curved out onto the sand. A new series of home lots then appeared in front of the Six Sisters but were purchased by the owners to preserve the view. (Below courtesy of Santa Cruz Museum of Natural History.)

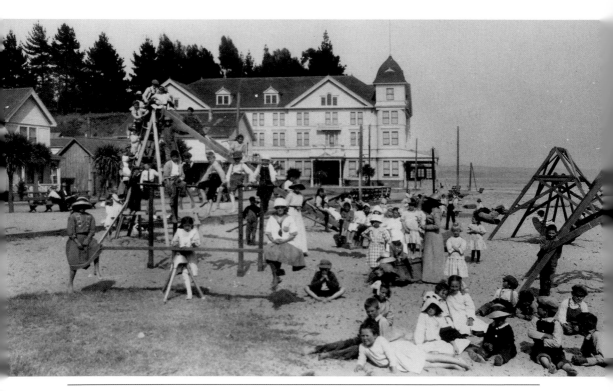

Capitola's beachfront has been a popular destination for more than 130 years. Above, in a *c.* 1910 photograph by Ole Ravnos, children are playing on equipment provided and maintained by the F. A. Hihn Company. Hihn kept strict control of the commercial district and the use of the beach, going so far as to fence it off from time to time. The building across from the Capitola Hotel was an early annex that later became a curio store. The beach was much wider in the early 1900s, but Ocean Front Avenue was moved out onto the beach in later years. (Above courtesy of Santa Cruz City–County Library System.)

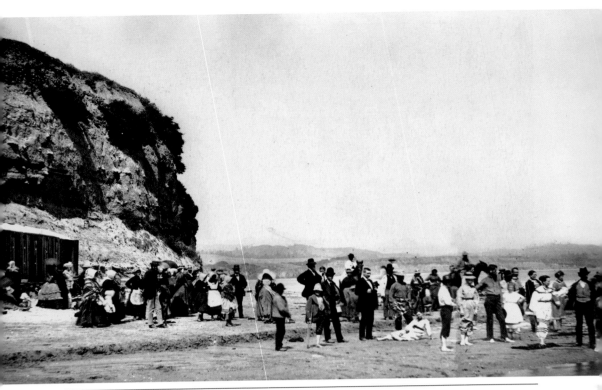

Very few visitors to Camp Capitola wore bathing suits when the above photograph was taken in the summer of 1875. This group of men and women are standing at the east end of Capitola beach, just seaward of where the first Capitola Hotel was to be built 14 years later in 1883. The structures on the left side of the photograph are changing rooms. Esplanade Park and public restrooms now occupy the site. (Above courtesy of Special Collections, University Library, University of California Santa Cruz.)

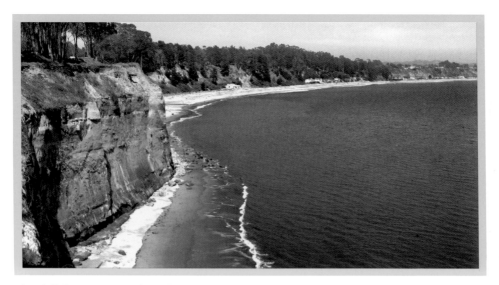

The cliffs between Capitola and New Brighton State Beach are prone to failure due to the joint or fracture patterns in the rock. Slabs and large blocks have continued to fall or slide from the cliffs for as long as the cliffs have existed, as evidenced by the rock on the beach. Several small cabins that can be seen in the distance at the base of the bluff in the *c.* 1920s photograph below are forerunners of present-day Pot Belly Beach, a private beach level development. (Below courtesy of Special Collections, University Library, University of California Santa Cruz.)

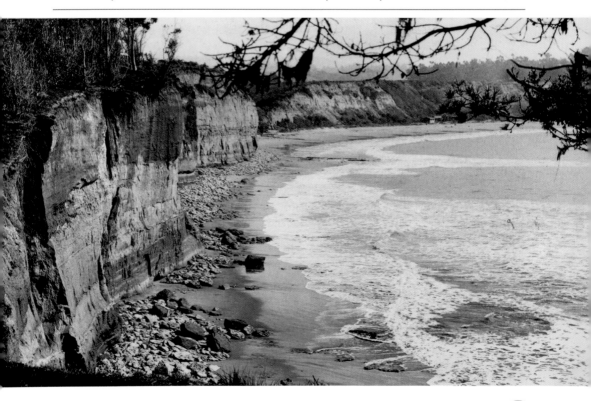

The *c.* 1930 photograph below shows one of the Pot Belly Beach houses in the foreground and the SS *Palo Alto* at Seacliff in the distance. The Seacliff and Rio del Mar shoreline was initially developed in the 1920s, slowed by the Great Depression in the 1930s, then grew more rapidly in the 1950s and 1960s. The storms and high tides of the El Niño–dominated period that extended from 1978 to 1998 battered many homes. (Below courtesy of Santa Cruz City–County Library System.)

CAPITOLA TO RIO DEL MAR

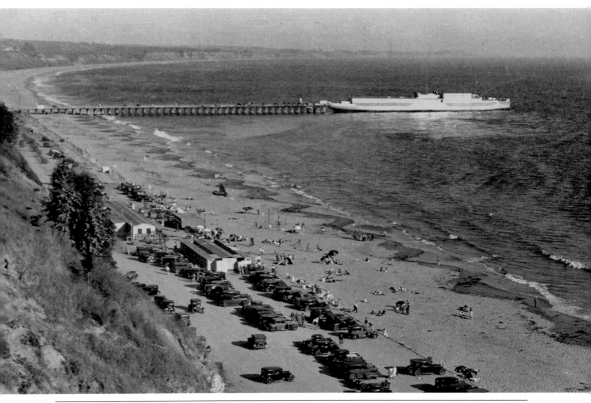

The c. 1930 photograph above of Seacliff Beach State Park was taken from the bluff top and shows that automobiles were down on the beach even in the 1930s. The Cement Ship in the background, the SS *Palo Alto,* was designed as an oil tanker and was to be part of a fleet of concrete ships built in 1918–1919. The ship finally made it to sea on January 21–22, 1930, when it was towed from San Francisco to Seacliff Beach. (Above courtesy of Santa Cruz City–County Library System.)

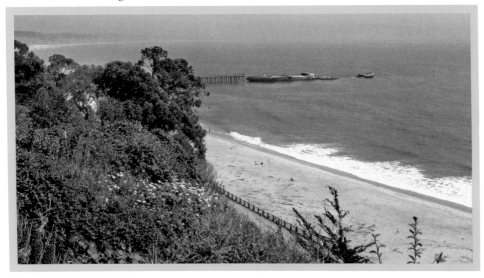

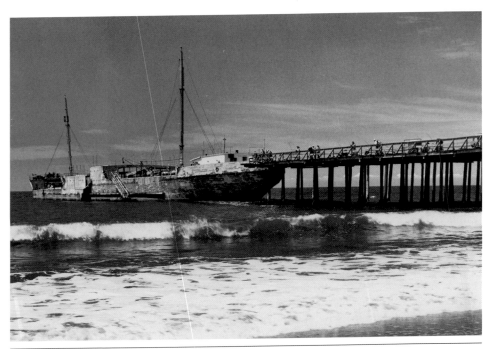

Although it was built out of concrete, the SS *Palo Alto* is known locally as the Cement Ship. Designed as an oil tanker using local Davenport cement, the ship was one of a fleet of concrete tankers built toward the end of World War I. The war ended in 1918 before the ship was completed, and eventually it was sold as surplus and towed from San Francisco to Seacliff. It was sunk in shallow water with its bow facing out to sea, and a 600-foot pier was built to connect its stern with the shore. For two years, it was an amusement center complete with ballroom, restaurants, and concessions before closing in the Great Depression. The above photograph was taken before 1934, when the ship's equipment and superstructure were sold to a local wrecker for salvage. In 1936, the ship was sold to the State of California for $1 and incorporated into Seacliff State Beach, where it has become a favorite fishing platform. (Above courtesy of Santa Cruz City–County Library System.)

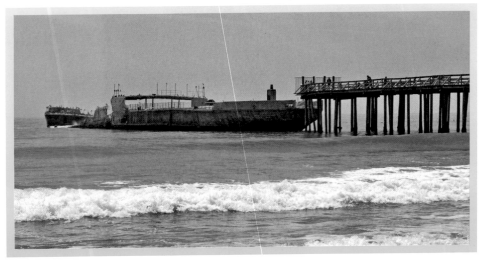

CAPITOLA TO RIO DEL MAR

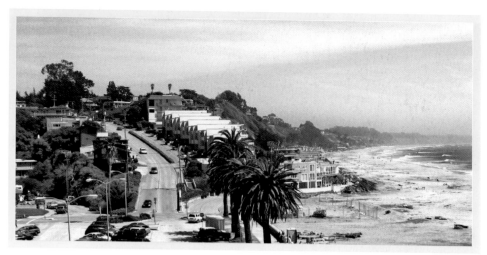

The present-day Rio del Mar Esplanade was originally laid out in the mid-1920s, and the configuration of Rio del Mar Boulevard at the bottom of the hill is still the same as it was in 1929, although the small palm trees are now fully grown in the 2006 photograph above. In 1929, the 22-room Hotel Don Rafael de Castro was built atop the hill overlooking Monterey Bay. The hotel went through several name changes over the years, including the Rio del Mar Country Club Inn. When it was destroyed by fire on the evening of March 17, 1963, it was named the Aptos Beach Inn. Despite the Great Depression, a number of houses were built in the Rio del Mar subdivision in the 1930s and along Beach Drive that runs between the beach and the base of the bluff. The postwar building boom and the coming of Cabrillo College to Aptos in 1962 helped spur additional growth—evident in the contemporary photograph. The severe El Niño storms and high tides of the period between 1978 to 1998 damaged many houses on the beach, but as disaster memories are short lived, building and rebuilding on the beach continues. (Below courtesy of Special Collections, University Library, University of California Santa Cruz.)

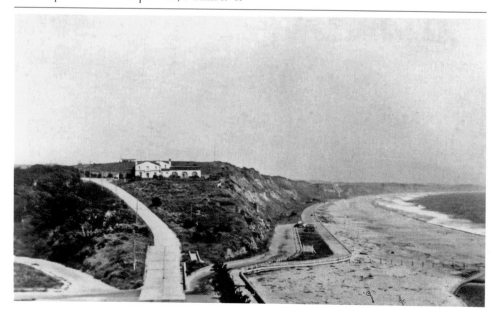

Across America, People are Discovering Something Wonderful. *Their Heritage.*

Arcadia Publishing is the leading local history publisher in the United States. With more than 3,000 titles in print and hundreds of new titles released every year, Arcadia has extensive specialized experience chronicling the history of communities and celebrating America's hidden stories, bringing to life the people, places, and events from the past. To discover the history of other communities across the nation, please visit:

www.arcadiapublishing.com

Customized search tools allow you to find regional history books about the town where you grew up, the cities where your friends and family live, the town where your parents met, or even that retirement spot you've been dreaming about.